D1578727

£.85

BRIDGET RILEY

DIALOGUES ON ART

BRIDGET RILEY
DIALOGUES ON ART

With Neil MacGregor, E.H. Gombrich, Michael Craig-Martin
Andrew Graham-Dixon, Bryan Robertson

Edited by Robert Kudielka
Introduction by Richard Shone

Thames & Hudson

This book is based upon edited transcripts of the BBC Radio 3 series
Bridget Riley: Five Dialogues on Art, produced by Judith Bumpus
and first transmitted on Radio 3 on 7, 8, 9, 10 and 11 December 1992

First published in the United Kingdom in 1995
by Zwemmer and Philip Wilson Limited, London
This edition first published in 2003
by Thames & Hudson
181a High Holborn, London WC1V 7QX

British Library Cataloguing-in-Publication Data
A catalogue record for this book is available from the British Library

ISBN 0-500-97627-9

Designed and typeset
by Richard Hollis and Christopher Wilson
Co-ordinated by Ridinghouse, London
Printed and bound in the United Kingdom
by The Westerham Press

Contents

Foreword

The dialogues in this volume were originally produced by Judith Bumpus for BBC Radio 3. It was her idea, following Bridget Riley's Hayward Gallery exhibition in 1992, to set up a series of dialogues in which the artist would talk about her work with various well-known figures from the art world. She also edited the version of the recordings which was transmitted in December 1992 and repeated in August 1993. The success of the series owed much to her determination and skill, and the present publication would not exist without her generous encouragement.

The transcript of the recordings confirmed the impression given by the broadcasts. These five dialogues form a coherent statement of the ideas and experience of one of the most distinguished painters working today. It should come as no surprise that such a document took the form of conversations. Over twenty-five years ago Riley described her creative work as a 'dialogue between my total being and the visual agents which constitute the medium'. Quick exchanges, contrasts and sudden shifts of ground are the milieu in which her artistic intelligence seems most at ease. In establishing the text I thought it important to preserve this vivacity while at the same time eliminating inevitable colloquial redundancies and clarifying those points which, although easily understood in talking, become unintelligible when written down. This could only be done with the close and patient collaboration of the artist, who gave a lot of time and thought to getting it right. I am also very grateful to the other authors for reading and approving their contributions. Richard Shone has written a perceptive appreciation of the artist's personality and achievements.

Because considerable ground is covered in these dialogues it seemed helpful to introduce annotations in certain areas. Some simply provide additional information, others identify sources; and by far the largest group refer to previous statements by the artist which may elucidate a point that is only loosely touched upon in the present context. At the end there is a list of these further documents and a short biography.

Dialogues on Art was first published in 1995. This new edition reprints the text unaltered. Apart from the layout and a few additional reproductions

only the references to Riley's own writings have been revised. A more extensive account of the artist's life, and easier access to her early texts, is provided by *Bridget Riley: The Eye's Mind* (1999), a collection of the artist's writings and interviews from 1965 to 1999.

The reproductions and illustrations accompanying the dialogues have been selected by Bridget Riley. All who have worked on this publication and its new edition will wish to thank Karsten Schubert for his commitment and invaluable support.

Robert Kudielka

Introduction

by Richard Shone

Bridget Riley is unique. For thirty-five years or so she has been an independent and individual voice in British painting, single-mindedly devoted to her work. Nothing has deflected her from her chosen path; and no one else of her generation has pursued so rigorously modernist a programme with such unwavering fidelity. Yet she is no recluse, hermetically sealed against distractions: her studio has windows on the world. She holds passionate convictions about the role of the artist, about the central importance of art in society, about the relationship of the art of the past to its contemporary manifestations. She articulates her views with eloquent clarity, avoiding jargon and sophistry. Yet in some senses she is an unknown quantity. While wanting her painting to be seen, known and enjoyed, she has never felt a compulsion towards self-advertisement. Hers is not a familiar face on television or in the press and she generally eschews the time-wasting trappings attendant on being 'well known'. There was a time, however, when the world's attention was inescapable, the time of her great celebrity in the 1960s and early 70s. In New York, as can be seen from her trenchant account here (p.69), the fame back-fired. In Britain too, her celebrity had its drawbacks. She refused to play the game – unlike some of her contemporaries – and by the later 1970s she seemed not exactly to have disappeared but rather to have been muted, to have lain low. This veiled retreat coincided, in the early 1980s, with the discharge of an international resurgence in figurative painting, and there appeared to be, in the public eye at least, little room for her uncompromisingly non-figurative work. This was especially so in Britain with its long-held suspicion of abstraction, particularly of the unmediated and precisionist kind that Riley espoused. Her work neither reminded people of landscapes they knew nor evinced highly-charged subjective responses.

 Undistracted, Riley painted, bringing her formidable intelligence to bear in directions that arose naturally from the established trajectory of her concerns. The visible changes in her work, changes of attention and focus, the leap into colour, new tempi, only pointed up the underlying consistency

of all her work. This efflorescence of her palette and a mastery of spatial organisation, with no occlusion in a vision that has always been both austere and hedonistic, inevitably attracted renewed admiration.

Riley's current fame is more firmly based, rooted in abundant achievement and secured on her own terms. At the same time, other factors have contributed to this newly won, high profile. Dazzlingly alive though it is, her early black-and-white paintings – works such as *Blaze, Fall, Crest* – have become part of history and take their rightful place in any account of post-war art. Whereas the work of some of the best-known practitioners of her generation now looks meagre and dated, Riley's has classic status. Moreover, in the later 1980s her painting began to influence a variety of younger artists, particularly in Germany, the United States and Britain, a sure sign of continuing life. Although she may disdain the wrong kinds of publicity – and one of her strengths is an ability to distinguish the good from the bad – she is by no means inaccessible. In the last few years she has accepted several invitations to write and lecture; she has been filmed and interviewed; she has served as a trustee of the National Gallery; she is patient with thesis-writers and knows fellow artists across the generations. She will talk about her painting with the same frankness and objectivity that she brings to discussions of the art of the past and the painters who have made their mark on her development.

For those people coming to the dialogues in this book for the first time, there is inevitably something missing from their transcription – Bridget Riley's voice and her characteristic manner of talking. Without ever being affected, it is an educated voice, succinct, unidiomatic, unwasteful of words; it has a surprising tonal range to it but is most typical when she is gravely ordering her thoughts like a cat fastidiously picking its way along a crowded mantelpiece. There is a just discernible sense, sometimes, that an alternative answer to a question might be possible, usually suggested by an initial hesitancy, as she gauges the context. Short stops between phrases denote her search for the right words; a gleam in the voice, her successful re-arrangement of the furniture of her argument. All this is punctuated by encouraging laughter, for humour ripples through these interviews to leaven serious topics. Furthermore, she answers the questions in such a way that a real conversation develops rather than the bat-and-ball of an interview. As such, one longs for them to continue, even though enough points are touched on to last a lifetime. All the major issues of painting are raised

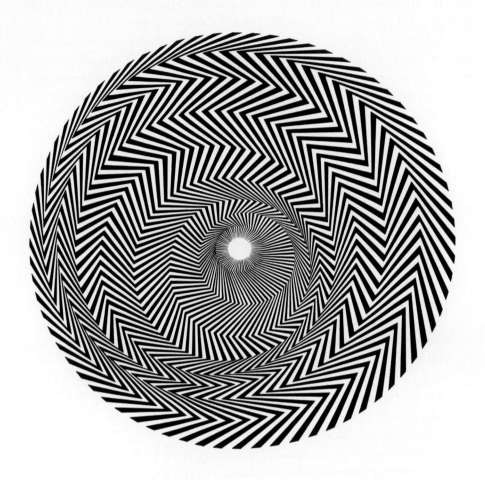

Blaze 1 1962

and illuminated – the nature of colour, of pictorial space, its internal laws and liberties, form, subject matter, content, the relation of feeling to image, habits of seeing, the tug of tradition and the pull of the present.

On the last topic, Riley is particularly suggestive. All her working life she has unashamedly measured her ambitions against the achievements of great names – in painting, music, literature. They act as both milestone and signpost and only the great names can assume such roles. For the most part, she has chosen figures belonging to a Mediterranean-based culture – either through birth and inheritance (such as Mantegna and Cézanne) or through a deliberate intellectual and emotional journeying (such as Poussin and Stravinsky). Although she is by no means insensible to other cultures and climates, as these conversations record, the example given here of her distaste for the work of Caspar David Friedrich speaks eloquently for what has not meant anything to her. Painting should not be a vehicle for what seem, to her, essentially literary ideas which water down the aesthetic input, no matter how interesting or moving those ideas may be as literature. She has the ability to detach herself from the implications of subject matter, whether it be an Adoration or a lilypond, a tumultuous pagan revel or a Provençal pine tree, and get to the heart of why such a work should so profoundly move us, without, at the same time, diminishing the importance of the subject as a springboard. She can put on hold all those preoccupations of a strictly non-aesthetic kind – preoccupations that in recent years have tended to over-whelm much writing on art – and lead us, momentarily perhaps, for it is as elusive as stardust, into the act of making.[1]

In this context, Riley's conversation with Michael Craig-Martin is particularly revealing. In talking about abstraction, there is no sudden change into a language or attitude different from her discussion with Neil MacGregor of a complex figurative painting such as Poussin's *Adoration of the Shepherds*. She has an unshakeable belief in the efficacy of paint itself to embody and convey profound emotions, whether she is considering a full flower of seventeenth-century Venetian art or the most spare Mondrian. On the other hand, the subject of a painting is a bonus and, while it may act on the viewer as an immediate enticement (or, indeed, a repellent), its representation is valuable only in so far as it suggests aesthetic content. What after all could be more mundane than Seurat's stretch of riverbank, or more commonplace than a nursing mother? And what could be more elementary than abutting stripes of colour? In Riley's own work we find no subject as such and her language has always been consciously restricted to a basic vocabu-

lary. Yet her frank insistence on the act of looking, the scrutiny of the concept, becomes an equivalent of a subject. By banishing from her work gestural and suggestive handling and the accidents of perceptual representation, Riley presents unmediated looking. Of course, what we as viewers bring to what we see is undeniably complex, an overflowing baggage of past experience and present mood. But her clarity of thought and its economic translation onto canvas surely demand a similar rinsing of our eyes and minds.

In the last two conversations printed here, particularly the one with Bryan Robertson about her travels and pleasures, we discover some of the sources of Riley's inspiration – visual sensations and incidents, simple and complex, domestic and foreign, public and private, urban and rural. While the examples she gives are of great interest, they must never be mistaken for what her paintings are about.

In recent years, commentators on her work have been eager to pin readings to it, to affix explanatory labels drawing them into a world of shared experience. We cannot say that these are wrong: we know too little and too much about the peculiar and unexpected ways in which images reach their final form. And certainly we can be sure that someone as alert and responsive as Bridget Riley digests a mass of sensations and emotions that fertilise what she gives us on canvas. But it is well to remember Seurat's remark that people 'see poetry in what I have done. No, I apply my method and that is all there is to it'. He is as protective in this as Virginia Woolf who, exasperated by interpretations, wrote that 'I meant nothing by the Lighthouse' or as Stravinsky who passionately asserted that if 'music appears to express something, this is only an illusion and not a reality'. It is characteristic of Riley that when Bryan Robertson leads her to talk about Proust, she's not impelled to run on about love and jealousy, about French society, about Odette and Albertine. Instead, she plunges into one of the greatest passages in literature on the workings of the creative imagination, of how an artist makes something, spurred on by the most apparently trivial incident – the slip of a foot on an uneven paving-stone. Until that moment, door after door had seemed closed against the narrator's search to give form to his material; then, by accident, Marcel 'stumbles without knowing it on the only door through which one can enter...and it opens of its own accord'.[2] Something of the elation of such moments is suggested in Riley's remark that, when temporarily becalmed and re-thinking her work, 'I often find a clue to the next step in identifying what I have come to rely upon most and challenging precisely that'. It is for such insights that these conversations are

valuable, moving from tested particularities to general application. Readers with quite different views from Bridget Riley on what constitutes a work of art will surely gain nourishment from her observations, gathered here with such persuasive clarity and enthusiasm.

1 An extended example of this is Riley's analysis, centred on colour, of Titian's *Danae* (Prado, Madrid) given in her Darwin lecture 'Colour for the painter', published in *Colour: Art & Science*, Cambridge University Press, 1995.
2 Marcel Proust: *Remembrance of Things Past*, vol. 12 ('Time Regained', Part II, p. 222), English translation by Andreas Mayor, 1970.

DIALOGUES ON ART

The Art of the Past

talking to Neil MacGregor

Bridget Riley, the public of course knows you best as an artist, but I know you best as a trustee of the National Gallery, which you were for seven years.[1] Seven very difficult years, during which we ultimately managed to solve the problems of the new building and to open the Sainsbury Wing. As a trustee, you were responsible for many of those really big decisions that changed the face of the National Gallery and you must have formed a view about what the purpose of a great collection of Old Master paintings in a modern city was. How do you see the job of the National Gallery?

I think its role has never been as crucial as it is today. It has a huge public and people need contact with the kind of values that the work in the National Gallery embodies. As the world becomes more and more difficult for us to live in, I think that the value of the collection becomes more and more important.

The collection was of course set up so that the poor of the day, the public of the day could take refreshment in great pictures. And I think we all sometimes worry whether pictures from the 14th century, from the 17th century, can still give pleasure easily to a public that doesn't know about the world they came from. Do you think we need to explain pictures like the great mythologies, or do you think the public can enjoy them as pictures without knowing necessarily where they come from?

Fundamentally the public enjoys the paintings for what they are, as beautiful spiritual works of art. I don't think that they really need to know the mythologies or the religions involved. I think that knowledge of them is interesting and that it can add to and, at best, increase one's enjoyment, but I think the real heart of public pleasure in works of art lies in something much more mysterious and more potent.

So it's a straightforward visual experience above all for you?

The medium is visual, but what one is experiencing is above all beauty, and I do not think people are unmoved by something beautiful, or by the generosity of spirit which accompanies it. The greater the work, the more the artist has given to it; it is that gift which is transferred through the work right across centuries. I think that is the point of contact, that's what people feel and what they take away, and why they feel somehow reassured.

This is of course exactly what Peel and the other great Victorians, who set the National Gallery up free of charge, would have wanted to hear, isn't it?[2] *That the spirits of people were uplifted and tranquillised.*

Oh, I think, not just tranquillised. Can I for a moment go back to the life of those works before a collection such as the National Gallery was formed and opened to the public? People will have preserved and loved those paintings in their homes, in churches or wherever they were. Long before art history was even thought about, they have been prized and cherished, have had a meaning for people. And I think it is that – a kind of envelope and not just a pedigree – in which they come. A public collection as such is a relatively late idea in the life of those paintings and in the history of the role they've played.

So what do you expect your public now to bring to the National Gallery? What qualities do you want in the visitor?

I wouldn't really ask for any particular qualities from the visitor. By which I mean, the paintings are the welcome, make the gesture and by their very nature *they* are the hosts. The institution is the framework and those who run the institution are responsible for setting the scene in which those mute, silent works and today's public meet.

The other group, of course, for which the National Gallery was set up, one particular group which the founders had in mind, was the artists of the day. It was always hoped that artists would work in the National Gallery, would copy and study, and that this would improve British painting. Do you think that's still a proper purpose of a public gallery?

Artists are very lucky today in having public galleries where they can see and get to know work from virtually all over the world. There was, in the

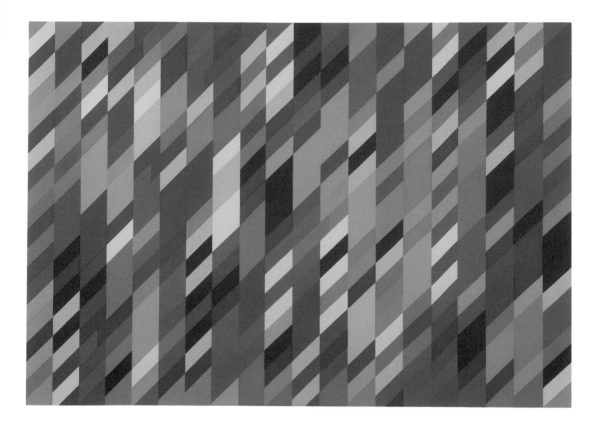

Nataraja 1993

early part of this century, an intellectual fashion which demanded the closing of museums, even the burning of works, as the Futurists threatened to do. This iconoclastic violence was perhaps necessary to break down certain creative inhibitions at that time. But now it's an extremely sad and mistaken thing for an artist not to look at the past. I think it impoverishes one enormously.

In your work, do you feel you've drawn heavily from paintings of the past?

Yes, I have. There are, of course, barriers. I was first able to make contact with many of those works simply by falling in love with them, by being excited by them. And once you're captivated, then through that fascination you begin to see and to find your way around in them. So that, without you really noticing it, you find yourself crossing quite formidable barriers, both technical and intellectual.

When you talk about paintings, both for us, the public, to look at, or for you, as artists, to study, you talk very seriously about certain kinds of high spiritual response. I find with a lot of the pictures in the National Gallery, that the narrative is very moving, often very diverting, that there's a great deal of humour, but there's also a great deal of fear. They're unsettling rather than straightforwardly exalting. Do you find the same?

Well, they're so *alive!* They are like people, with all those things. They show every possible characteristic without excluding contradictions. Some are more retiring, some are more extrovert, and they have moods. They're not static things, they don't come across as a fixed entity. A painting will reveal itself as a personality does, slowly over many visits.

As you say, particular pictures speak to you through particular preoccupations of the moment. So how do you respond to a picture I know you admire, the small Poussin Adoration of the Shepherds?[3] *It's not a large picture, it's conceived very much in browns and blues, and it's a work which I think many visitors might easily walk past, especially in the context of the much more coloured Poussins, the more ambitious compositions. Why would you as an artist want to stop in front of that one?*

It's an extraordinary composition. At first glance the top and the bottom of the painting seem totally divorced, and yet how beautifully Poussin

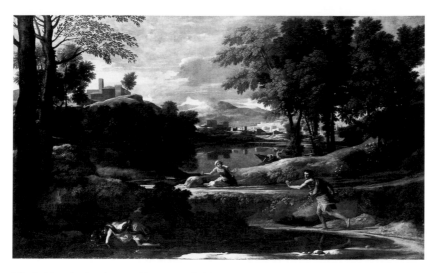

Nicolas Poussin: *Landscape with a Man killed by a Snake* 1648

connects the two parts through colour and his use of diagonals. It may seem a small and modest work but it is a great painting. The other day I was looking at his *Landscape with a Man Killed by a Snake* and what is so astonishing about that painting is the power of the rhythm which swings in a series of gigantic loops across the painting. I've always loved that movement which begins with the figure running in, turns half way up, in the figure with arms outstretched, and is pushed round the edge of the lake. But what I hadn't seen before is that, not content with leading you right into the heart of the painting, he actually repeats the whole rhythm back again towards you: from the city in the centre back, through the hills, up to the fort and across the crown of trees in the front. So the huge speed of the painting is made not by one but by two great looping rhythms mirroring one another.

This sounds very much like your own paintings in some ways, doesn't it – talking of Poussin in terms of looping rhythms, diagonals, colours, balance? They're the sort of words that I would be using if I was trying to explain to someone my response to your pictures.

I suppose it's inevitable that one will in part carry one's interests over into another work. One always begins by understanding the things one has already experienced. That's how one starts to find out something new.

I would like to go back to the Poussin painting of The Man Killed by a Snake, *which I find one of the most frightening pictures in the National Gallery. It seems to me that it perfectly captures our apprehension of something near but nameless – some threat that is almost disabling. I think it is one of the most powerful 17th-century representations of* angst *that I know. When you talk about it, you suggest to me that that fear, that apprehension, is resolved formally – do you think that this is the case? Or do you find it as unsettling as I do?*

I don't find it quite as unsettling as you seem to. I find it mysterious.

Mysterious, not frightening? I find it like a Polanski thriller.

[*Laugh*] Well, I must go and look again, because I'd hate to miss that. It is certainly an exciting painting, but what I find thrilling about it is that it shows an aspect of nature which one feels is always there, just under the surface. Poussin has placed it at the base of his canvas, below the people,

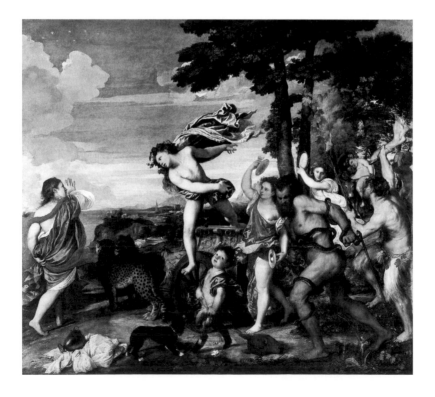

Titian: *Bacchus and Ariadne* 1522–23

below the city, below the sky, below everything which rises from it. By this positioning it's turned into something fundamental. In that sense I don't find it frightening but rather more a basic condition.

And on that fear and uncertainty order has been constructed?

Precisely. The daylight begins, the people move, the cities are made.

It turns into your kind of painting in fact [laugh]. You talked, Bridget, about your personal response and the importance to you in your work of the paintings of the Old Masters. But is there a generalised way in which painting now can be seen to relate to the great tradition before Cézanne? We've all been so brought up to think of a disjunction around the beginning of this century; do you think it is possible to look beyond that period in painting and see strong continuities from the Old Masters?

Yes I do, but there's no general continuity as such. One can see connections between the art of the past and modern art more clearly in some paintings than in others. For instance, Titian's *Bacchus and Ariadne* is a more 'modern' painting than his other works in the collection. In that canvas he has organised 'how we should look' in a way that directly relates to Cézanne's approach.[4] Titian takes two blues and an off-white from the colours in the sky – the farthest distance – and moves them down into the foreground as a skirt, a cloak and a dress. By doing so, he tips the picture plane flat. That kind of thinking is the same sort of thinking as in a Cézanne where the foreground in front of a mountain is pushed back by introducing the sky colours there and conversely the background is pulled forward by taking the green of the foliage up into the clouds. The same can be seen in a still life in the way that the far side of a dish of fruit is tipped up, the front of a table pushed down and the drapery and fruit stacked vertically. This type of interrelationship between planes and colours clearly exists in Titian, and that is absolutely modern.

What you're talking about is very much a way of manipulating our perception, isn't it, which Titian, Cézanne and others have done? But Titian's contemporaries talked also, I think, about the fact that he discovered beauty in places people hadn't previously seen it – the well-known cliché that it was Titian who showed us all how beautiful sunsets were. Do you find, looking at other pictures, that you discover visual beauty that you hadn't previously noticed? Or is it much more a question of how the perceived world is adjusted?

No, of course one discovers. Painters bring their observations and insights to the worlds they present. Sometimes they may be an enhancement of things you have already glimpsed, sometimes they are absolute surprises. For a long time I had not noticed a frieze by Mantegna in the National Gallery, *The Introduction of the Cult of Cybele at Rome*. The subject is the carrying of a statue into Rome. I was amazed to see that Mantegna holds together the narrow horizontal format of his frieze in one long, all-embracing rhythm. The verve with which the first figure steps in, is stopped, cut short by the straight line of the statue, as though by an enormous comma; then this movement, introduced by the first figure, is picked up by the next two, turned round in the supplicating figure and continues in reverse until the very last figure where it changes back to echo the first.

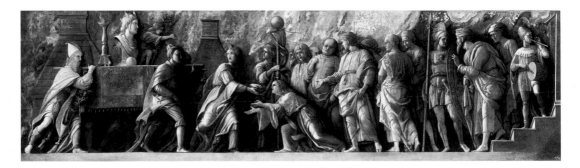

Andrea Mantegna: *The Introduction of the Cult of Cybele at Rome* 1504–5

That's a very musical way of analysing a painting.

It is an extremely musical painting. It is impossible for Mantegna to have made that painting without thinking in musical terms.

I'm sure he'd be very pleased to hear that. Do you see your own paintings in musical terms?

Yes. Painters have always been aware of a correspondence between music and painting. I think it is because painting is basically an organisation – or 'manipulation', as you would say – of abstract qualities that bear no direct relationship to the physical world. This poses the question of *how* this is to be done: being both a sensual and an abstract thing, music does provide a model. In music you have reversals, fast and slow speeds,

densities and passages of dissipation and so on. In paintings like *Bacchus and Ariadne*, and in the Mantegna, you can see the painter's mind working in that way.

You talk constantly about mind, about the organisation, the intellectual structure of a painting, the manipulation of a painting. What you haven't talked about is technique, and technical competence. It would be possible, after all, to challenge your admiration for Poussin by pointing out that he didn't actually put on the paint either thickly enough or competently enough to stop the red ground showing through and great areas of the picture becoming illegible. One could challenge Titian's use of greens that have discoloured – which could probably have been avoided. Does that worry you – the technical competence – or do you think it very secondary to the intellectual construct?

I think the two go together…

But they clearly don't…

You're talking about something that's happened over a period of time. I'm sure that when those paintings left the studio they were technically perfect. They would *have* to have been. The immediate audience would have required it. As a painter, you simply don't think as a conservationist would. I think of technique as an intellectual ordering, a putting of the mind into a series of actions which are necessary. One of the things which is so wonderful about the National Gallery collection is the wealth of preparation that has gone into this, the respect for making a thing of love actually. It is necessary to plan, to work, to study, to endure, to conserve, all that is part of making something – and the physical aspect of a painting technique is only one part of this intellectual framework.

But so, surely, is the fact that some artists bother – I use a rather loaded word – bother to make paint that will survive through centuries, whereas others do not. Reynolds would be a very good example of an artist who clearly could have chosen paint that would have gone on giving us the same pleasure that it clearly gave his contemporaries. But he didn't. Does that worry you?

It's very much a question of your attitude to the *métier*, as it was called. Even if the painting is burnt the next day, even if you later put a knife through it, I think that it is important to make it as perfectly and

thoroughly as one can, because it's a gesture, a votive something, so it must be done for its own sake, as something in itself: that has nothing to do with its value, nothing at all. Value is another matter which other people can decide and is neither here nor there to you as an artist in making the thing.

One of the great tasks of a trustee of course is to buy pictures, new pictures, for the collection, to approve the proposals made for new acquisitions by the Director. You must have thought a great deal about what pictures we don't have in our public collections in this country and that you would like to see. I know I would love to see this country filled with Matisse. We seem to be very, very thin on Matisse, and I think we'd be a much happier country if we had more. But do you feel there are lacks in our public collections that you would like to see filled?

I quite agree with you about Matisse. Where are the Matisses that one can actually see? It is extraordinary that this great painter, who was working for more than the first half of this century and has long been recognised as an artist of the first order, is so poorly represented in public collections in England. You are perfectly right – we need that great shout of joy.

I think we need it very much at the moment.

Yes. [*Laugh*]

I remember when we were trying to buy, and did eventually buy for the National Gallery, the Caspar David Friedrich, you said, I thought very admirably, that you wouldn't take a view on it, because it was the kind of painting that simply didn't speak to you.

That's true. [*Laugh*] It didn't speak to me then, and I'm afraid it hasn't spoken to me since.

Are there many areas of what is now seen as the canon that simply don't speak to you? Because from what you've said already, you've ranged very widely across the collection and found things in almost every area. Is Friedrich one of your few dead spots?

He is one of what I hope are only a few.

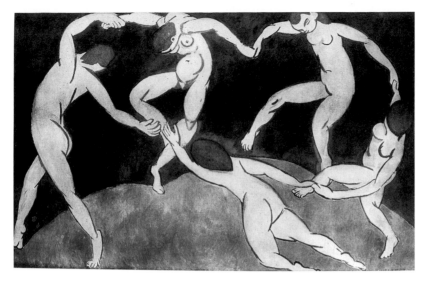

Henri Matisse: *Dance II* 1910

Do you know why?

It's his self-consciousness, the illustrational quality. The lack of density, the lack for me of aesthetic input in the painting. It's curiously thin, a sort of cardboard thing.

What we don't like is of course just as revealing as what we do like. I can see he's certainly not susceptible, as Romantic painting on the whole is not susceptible, to the sort of structural analysis that you applied to the previous pictures we talked about. Yet I find paintings of that sort moving because they seem to me to address a predicament in which a lot of us find ourselves. And I think that's a proper thing for paintings to do. Do you – would you at least concede that premise?

Yes, I can see it could be meaningful for people, but it seems to me that this whole sphere of feelings, of sensibilities, is not quite at home in painting. I think, in fact, that the Romantic spirit has very great difficulty with painting, it's far better in literature or music.

It's just the wrong medium?

Yes, it's simply that, the wrong medium.

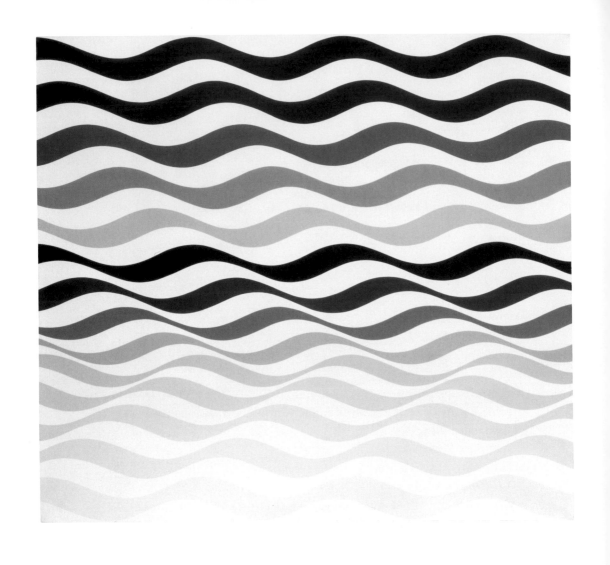

Arrest 3 1965

Bridget, we've talked a little about the problems we are told visitors might have looking at religious or mythological subjects that are not familiar. But I think I would argue that in fact those subjects are quite quickly accessible to everybody, because they're about people doing things, they're about people suffering or rejoicing. What I find difficult is to see how those central aspects of human experience can be addressed without figure painting in a traditional sense. But that's a question you must have tackled head-on, because you don't paint figuratively.

I think this is a very important question and a very big difficulty. It's as though a whole host of feelings, a whole group of impulses are without a context, without a place, without a sphere.

You mean there's no vocabulary available?

There is certainly no common vocabulary available to convey them. Figurative painting without the relevant context of religion or mythology won't do – it's no longer a language. I think that an artist today has to totally accept this lack, has to start from a 'placelessness', virtually as a point of departure. I can see no real alternative to abstract painting if, in fact, the painter wants to address those particular issues you mention, because the *absence* of a shared vocabulary is, by virtue of its absence, the only common basis that exists.[5]

And is there anything that the artist can do to make that abstract vehicle comprehensible to a wider public?

I believe that it can be sensed. It seems to me that a kind of formal thinking is capable of providing an equivalent to that missing universal vehicle. Properly treated, formalism is not an empty thing but a potentially very powerful answer to this spiritual challenge of an unavailable truth.

You talked about the Titian Bacchus and Ariadne, *which I know is one of your favourite pictures, with that marvellous moment of Bacchus leaping from the chariot. Now, I think anybody who didn't know the story would still realise that something life-changing was happening in that picture – this figure leaping in joy towards a rather alarmed Ariadne. Can that sort of tension be achieved without bodies?*

The tension, possibly. But it will take a long time. By which I mean that a large number of artists have to work over a long period of time to build up enough formal experience to have a framework in which these sorts of feelings can communicate. I doubt if they could ever be tied to a specific situation, as in a common religion or mythology, but they may be. It would have been unthinkable, I'm quite sure, for a Byzantine artist to have imagined what could be expressed by a Rembrandt. He would never have believed in his wildest dreams that it was within an art of depiction to reach such a level. One cannot tell what may be possible at a later stage. I think that I'm fortunate in that I have increasingly found an area in which I can give more myself. An artist nowadays has to make his entire context, his own criteria, has to explain, has to account for his procedure as it evolves. It's almost as though he has to take on the role of being his own public, his own critic, his own everything. As a modern artist you long to build up a large enough area of movement, something that can absorb you so completely that you can give.

I think it's revealing that when we're talking about pictures, either by other artists or by you, I've been trying to find notions of meaning in them of one sort or another. You have constantly responded by conceding meaning but focusing on generosity. On the giving by the artist to the work of art, first of all, and through the work of art to the public. What emerges, I think, from what you've been saying is the notion that artistic creation is in fact fundamentally an act of generosity. Do you agree with that?

Yes. But it is not personal, it's the work that gives. If I think of the pleasure I feel at the end of a concert, at the end of reading a book that has moved me very much, I feel that I have been given something. I think that is why one feels excited, relieved, enriched. Something has been added to your life by those things, in whatever form they may come. People have a strong instinct about what contains this necessary elixir for them. I think that this direct connection, long before there was such a thing as art history or looking after things for the sake of preserving our past in a conscious way, protected those great works which are now in the National Gallery Collection – saw that they were carried out of houses when those houses were on fire, saw that they were left to the eldest or most responsible child to be looked after, for no other reason than the preservation of this feeling.

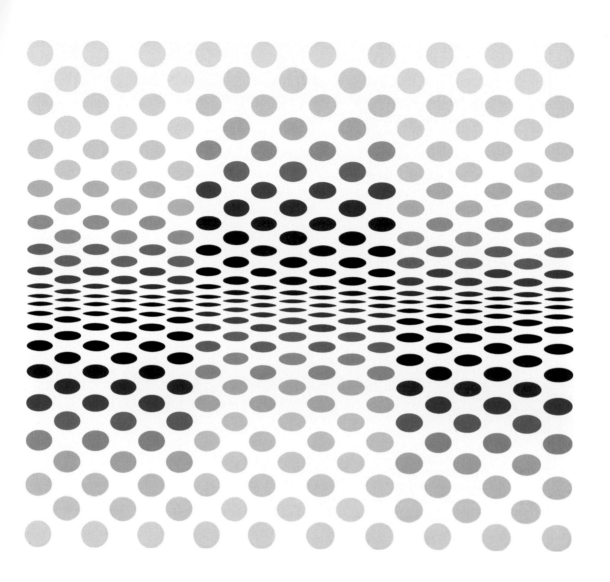

Where 1964

It's the sharing of that feeling that...

It's the sharing of that feeling which is the role of the Gallery today. And this, I think, if one looks at the expressions on many of the faces of the visitors to the Gallery, you see happening.

I can't think of a better way of explaining what the National Gallery is about. Bridget Riley, thank you very much.

1 During the period 1981-88.

2 The National Gallery was founded in 1824 by Lord Liverpool's government. Sir Robert Peel, as Leader of the Opposition in the debate on the building of a gallery for the National Collection in 1832, said that 'the exacerbation of angry and unsocial feelings might be much softened by the effects which the fine arts have ever produced on the minds of men' *(Hansard's Reports of Parliamentary Debates).*

3 This painting was included in Riley's selection of seven works from the permanent collection for an exhibition *The Artist's Eye: Bridget Riley* at the National Gallery in 1989. For a structural analysis by the artist see the catalogue text 'The Colour Connection', reprinted in *The Eye's Mind: Bridget Riley*, London 1999, p. 162 f.

4 Titian's *Bacchus and Ariadne* and Cézanne's late *Bathers* were the cornerstones of Riley's *The Artist's Eye* exhibition in 1989. Cf. *The Eye's Mind*, p. 142 f. and p. 168 f.

5 This point is further explained, emphasising the lack of 'focus', in Riley's statement in the exhibition catalogue *The Experience of Painting* (1989), reprinted in *The Eye's Mind*, p. 122.

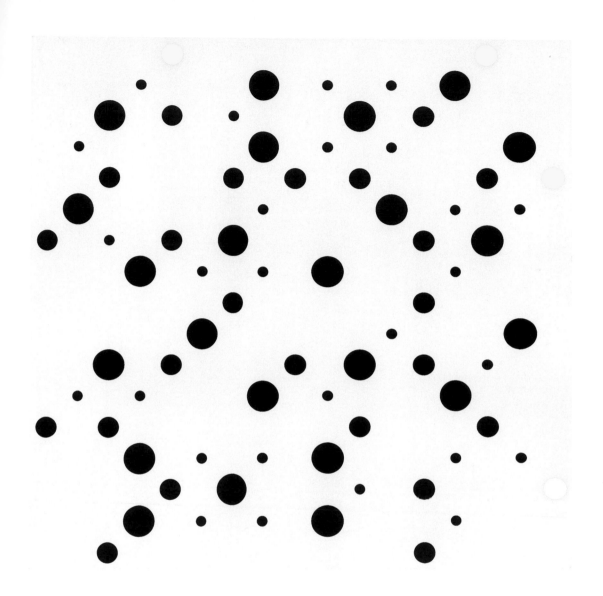

White Discs 1 1964

Perception and the Use of Colour

talking to E.H. Gombrich

I would like to start by asking you your views on Constable's pronouncement that painting is a science and should be pursued as an enquiry into the laws of nature. Constable continues that pictures may be regarded as experiments in that science.[1] What is your attitude to this idea?

I have always loved Constable, but I can't quite agree that painting is a science, or at least not what I understand by science. Nor do I think that his paintings are experiments. He was working at the end of a great tradition when painting had become stale, tasteful and 'historical'. Artists were imitating, quite blindly, 'the look of art', making paintings which looked like earlier great works but which didn't spring from original feeling or insight. In that sort of context studying atmospheric phenomena, *knowing* exactly what gave rise to the formation of a particular cloud for instance, set him free to respond in a fresh way to nature instead of simply exploiting what turned up in the way of paint blotches.

But surely it is observation he also had in mind? At that time observation was considered to be the key to a natural science, but I believe you have also said that in your own work it is not a theory of optics that interests you, but the appearance of things, and therefore the behaviour of light as you can observe it, rather than the optical reasons for the behaviour of light.

That is true. My work has grown out of my own experiences of looking, and also out of the work that I have seen in the museums and in galleries, so I have seen other artists seeing, and that has been an enormous help to me and a kind of pattern maker, in that it has shown me how a formal structure of looking is shaped and can shape in turn the way that one proceeds with one's own work.

So you prefer to look at pictures rather than to read books on optics?

Yes, I do.

I'm glad to hear that. And for that reason I suppose in your own work, you have always concentrated on particular problems which interested you, visual problems, rather than scientific problems, which you try to work out in exemplifications, as it were, by relatively controlled and clear juxtapositions of shapes at first, and colours later in your work, which have sometimes a very surprising effect, that you could not have predicted from the pure physics of the behaviour of light. Would you agree there?

I haven't studied the pure physics of the behaviour of light, but in the early 1960s I realised that the most exciting way of setting about work was to establish limits, in terms of each particular piece, which would sometimes push me and the work as we evolved together into such tight corners that they yielded surprising riches. It was like a forcing house: through limiting oneself, even severely, one discovers things that one would never have dreamt of.

I'm sure that this is so. But that of course has a parallel in science, and in a way also in our world of art, that the artist cannot roam all over the place, he must 'concentrate'. That is perhaps the simplest word. In your catalogue you quote a beautiful passage from Stravinsky about it. Would you like to read it to us?

It's from one of the six lectures on the making of music that Stravinsky gave at Harvard in the winter of 1939-40. They were published in a book called *The Poetics of Music*, which, along with Paul Klee's *Thinking Eye*, became one of my 'bibles' in the 1960s, and this particular paragraph struck a very powerful chord: 'My freedom thus consists in my moving about within the narrow frame that I have assigned myself for each one of my undertakings. I shall go even further: my freedom will be so much the greater and more meaningful, the more narrowly I limit my field of action and the more I surround myself with obstacles. Whatever diminishes constraint diminishes strength. The more constraints one imposes, the more one frees oneself of the chains that shackle the spirit.'[2] I think that's a very beautiful piece, and it became a guiding principle.

I found it immensely illuminating, that in connection with this problem of self-limitation, you write or say, 'if the modern artist is no longer subject to external restrictions, then this simply means that he has the freedom to set himself limitations, to invent, so to speak, his own sonnet form.'[3] I think that is a very beautiful and illuminating comparison, and it made me think of

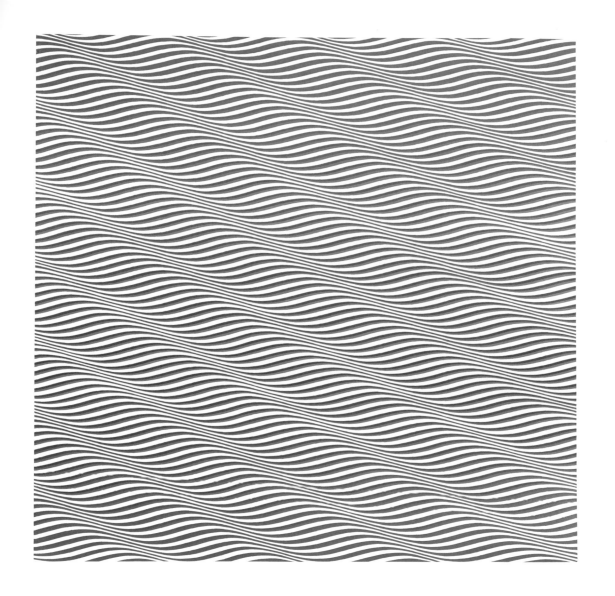

Cataract 3 1967

what Goethe said about the sonnet, which as you indicate in your quotation, is of course also restricted to fourteen lines and a fixed rhyme scheme. I cannot translate Goethe's sonnet about a sonnet in rhyme, but I've tried to make it at least scan. These are the concluding lines:

> This is the way with all types of creation:
> It is in vain that an unbridled spirit
> Will try to reach the summit of perfection.
> Self-discipline alone can lead to greatness.
> Accepting limits will reveal the master,
> And nothing but the law can give us freedom.

I believe that you must have experienced this freedom within the law in your creations which parallel the trying to write a sonnet.

Yes, I have. Those marvellous moments of freedom are the rewards, they are amongst the pleasures for which one works.

Do you think that you can predict these moments, or do they come unbidden, as a grace, as it were?

They come unbidden. I find that if they become…

Predictable?

Yes, predictable, then they lose their bite, they lose their vitality.

Lose their bite for you?

Exactly. Then I can't go on in that particular vein because the contact with what I am doing, the feeling of life, comes in part out of being surprised.

I see. It is the medium which gives you surprise?

Indeed it's the medium that surprises. One of the most wonderful things about painting is that its resources are inexhaustible.

It is the dialogue with the medium, if you like, I think you also said that somewhere.[4] I'm sure that it's very, very important.

Yes, until you get this dialogue going, you're getting nowhere.

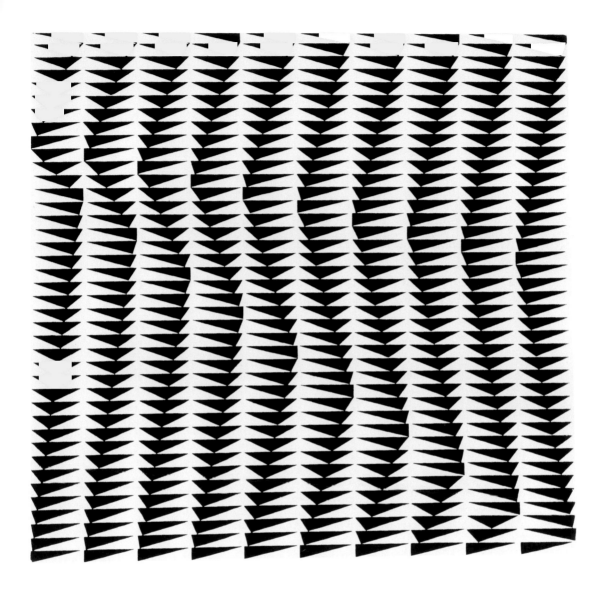

Shift 1963

You cannot simply lie in your bed and imagine what you will want to paint?

That's impossible!

It will turn out differently?

You cannot plan like that.

No.

But that, of course, is one of the most exasperating things about making a painting, because although one longs to use one's intellect as such, one finds that one cannot do so in the way one normally does. What is in that way viable turns out to be beside the point. It seems to be less a question of successive thinking than an instantaneous response.

You must remain open to what the medium wants?

Yes, and one will need all one's experience and flexibility to field it.

I'm sure it's a little similar to the chess player who knows all the openings by heart, but gradually it becomes unpredictable what is going to happen, otherwise it wouldn't be a game at all?

That's a good comparison.

The reason, I suppose, is that particularly as soon as you work with colours, the mutual effect of colours is indeed almost unpredictable because there are so many variables involved. We all know that if you put two colours side by side, the contrast may enhance them, or there may be what has been called the spreading effect, they may spread into each other visually, and therefore change in the other direction. I'm sure that in your work you must experience this all the time, and be both delighted and sometimes perhaps disappointed by this mutual effect of colour.

Yes, that is true, very much so, but it is also true of black and white. In my earlier work during the 1960s I found that they, along with greys, behave in a way somehow similar to colours, that is to say activities such as contrast, irradiation and interaction were taking place there too. I think

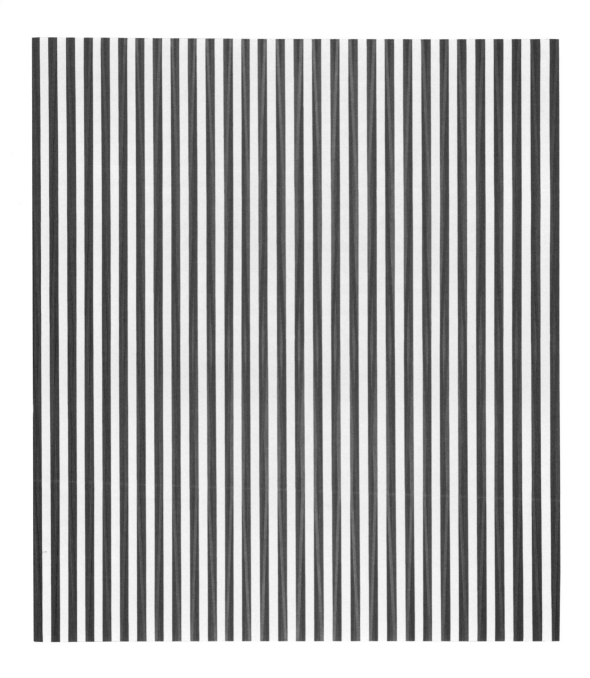

Zing 2 1971

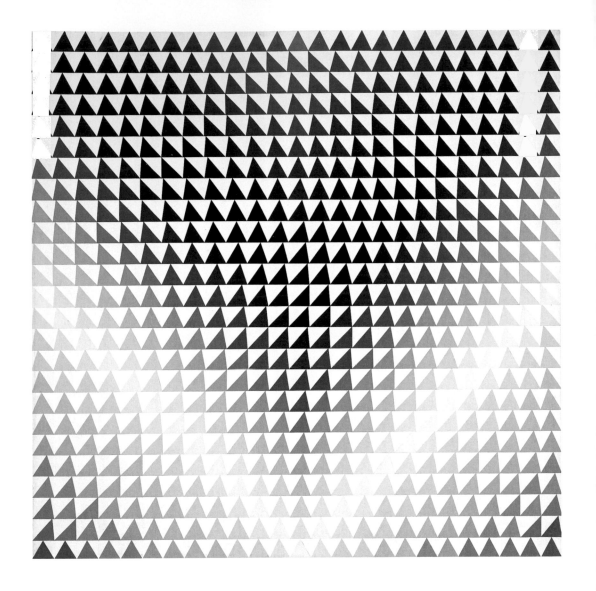

Burn 1964

that painters have known this for a very long time – there are a myriad sensations and one has to pick one's way through. There is a story of Delacroix running into Charles Blanc one night and explaining to him the secret of colour painting. He points at the muddy pavement saying 'if someone asked Veronese to paint a fair-haired woman with those colours, he would do just that and what a beautiful blond he would make on his canvas!'[5]

Wonderful, this is absolutely true, and in a way we may also describe it as scientifically correct. Even so, I am convinced that John Ruskin was also right, when he said that there are no rules by which you can predict these effects. If I may quote him at some length: 'While form is absolute...colour is wholly relative. Every hue throughout your work is altered by every touch that you add in other places … In all the best arrangements of colour, the delight occasioned by their mode of succession is entirely inexplicable. Nor can it be reasoned about. We like it, just as we like an air in music, but cannot reason any refractory person into liking it if they do not. And yet there's distinctly a right and a wrong in it, and a good taste and a bad taste respecting it, as also in music.'[6]

He's absolutely right. It's interesting that he makes this comparison with music. The common ground between music and painting seems to lie in the organisation of their abstract qualities. In music it's very clear, such things as the accumulation of sound, the dispersal of sound, the ebb and flow, the rise and fall, the contrasts and harmonies are arranged according to certain principles. In picture-making the masses, the open and closed spaces, the lines, tones and colours can be organised in a parallel way. It's as though these relationships are built up in all their complexity in order to provide a vehicle for those things which cannot be objectively identified but which can nevertheless be expressed in this way. Music articulates this indefinable content and it seems to me that this also applies to abstract painting, or at least the best of it.

You have talked about a cycle of repose, disturbance, and repose,[7] and surely this is at least in Western music, in our diatonic system, the basis of all music, the possibility of a resolution of a discordant sound in the cadence and so on. And I'm sure that here too, we have of course a scientific background in acoustics, as colour has a scientific background in optics, but acoustics alone have been shown not to work if you really want to analyse music, because in

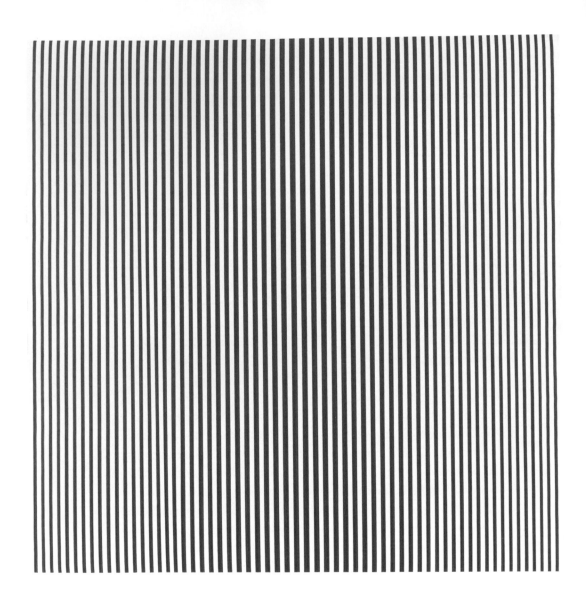

Chant 2 1967

acoustics, what is called even temperament has no place. That is to say the scales of our piano are not tuned exactly according to the laws of acoustics.

That's splendid – that's exactly the point. Simple regular symmetrical thinking does not take sufficient account of the imaginative relations and balances. Without that input, which 'beds in' sensation, one can't listen, interpret or look with any real precision and certainty.

Apparently our mind has many more dimensions or variables, or whatever you call it, than you would have been able to predict from the study of the physical correlates which form our sensations. It seems that in the last thirty years or so we have really moved away, or scientists have moved away very much, from the theories of vision which were accepted as gospel truth, and which we even have learnt at school, which place all the sensations in the retina and think that by explaining what happens in the retina we can explain how we see. This is obviously no longer a fact, that is to say, it never was a fact. The discoverer of the Polaroid camera, Edwin Land, showed in a number of experiments that the most surprising colour phenomena can be produced by using only two colours, something very similar to what Delacroix mentioned in the anecdote you told. And more recently neurologists, particularly Margaret Livingstone in Harvard, have probed the brain with electrodes and made other unpleasant experiments on monkeys and have really found that there are centres in the brain which respond only to colour, others only to shape, others only to movement, and these various systems interact in the most surprising and bewildering way, so that what another student of vision, J.J. Gibson at Cornell, called 'the awe-inspiring complexity of vision' has by now become a scientific fact.[8]

I think your account of those experiments just makes the precedence of Delacroix's observation so much more poignant. This probably dates back to his visit to North Africa. He noticed several interesting things happening in the appearance of objects. What his discoveries amount to is that taking a white cloth in sunlight for instance he saw there a violet shadow and a fugitive green – but it also seemed to him that he saw more colours than just those two: was there not an orange there as well? Because, he argued, in the elusive green he found the yellow and in the violet the red. Delacroix was convinced that there were always three colours perceptually present in what we see, and he found more evidence

in various other observations he made and concluded that the continual presence of three colours could be regarded as a 'law' in the perception of colour.[9]

Have you had similar experiences to the one of Delacroix in looking at a white piece of linen or any other such objects in the sunlight?

I have never re-run that purely as an experiment, but the second colour painting I made in 1967 – *Chant 2* – is all about this. I did not know anything of Delacroix's discoveries at the time, but as I worked on my studies I could see that something was beginning to happen: when the red and blue surrounded one another in stripes on the white ground they made two different violets and intermittently one saw a fugitive yellow – and I built the painting to articulate this visual energy as I called it then. I saw this as an instance of the innate character of colour when set free from any sort of task describing or depicting things. In nature this sort of thing happens more or less clearly quite often. In the Mediterranean landscape there is a quite common example that anyone can observe. If in the field of vision there should be a fair amount of ochre ground or rocks of an orange or an orange red, and maybe some strong green vegetation or turquoise green in the shallows of the sea, one will then see violets particularly along any edges where the oranges and greens are seen one against the other. In Cornwall a few years ago I remember a spectacular instance; looking at the sea coming in over little rocks – which was basically a few greens and a great many blue violets produced by various reflections – there was also – and this is important – quite a lot of dull orange brown in the seaweed floating in the water. As a result the whole surface of the water was flecked with tiny fugitive crimson points. It seems that as sight is always in action – is working all the time – whatever one looks at one cannot help but look through one's own sight.

Of course.

I have found that as a painter you develop a kind of screen or veil between you and external reality which is made up of your own practice or habits of seeing. Monet's *enveloppe* and Cézanne's *harmonie générale* are actually such fabrics or veils by means of which their perception is so heightened that they can penetrate further and with greater precision than they could without it.

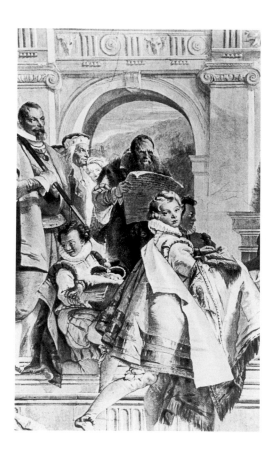

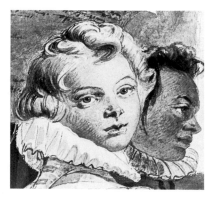

Giambattista Tiepolo:
details from the north wall
of the Kaisersaal in the Residenz
at Würzburg, 1750-53

*And in addition of course, as you said, it is the scale of the patches of strokes
of colour, which change the behaviour of colour in our perception, and
therefore when you step too far away and they become too small for the
interaction to have the same effect you aimed at, you may really see grey.
Was that what happened?*

Artists have usually held this very subtle question of distance and the
perception of their work in their minds when they are making something.
For instance, in Tiepolo's ceiling paintings in Würzburg, the blues over
yellows, the reds over greens, the brush marks which cancel out, or even
destroy, the purity of those colours, make instead a beautiful, luminous,
fresh grey which is what one sees from the floor, which I'm sure was his
intention. An artist does know – should know – the effect of distance, it's
part of his work to understand those things.

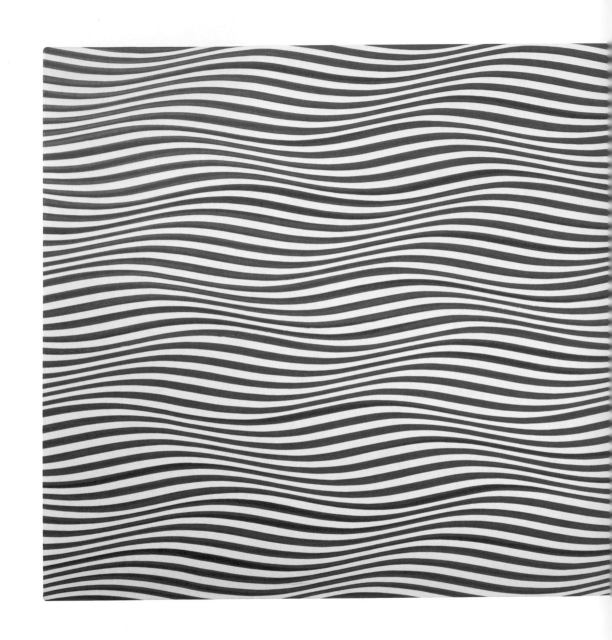

Streak 3 1980

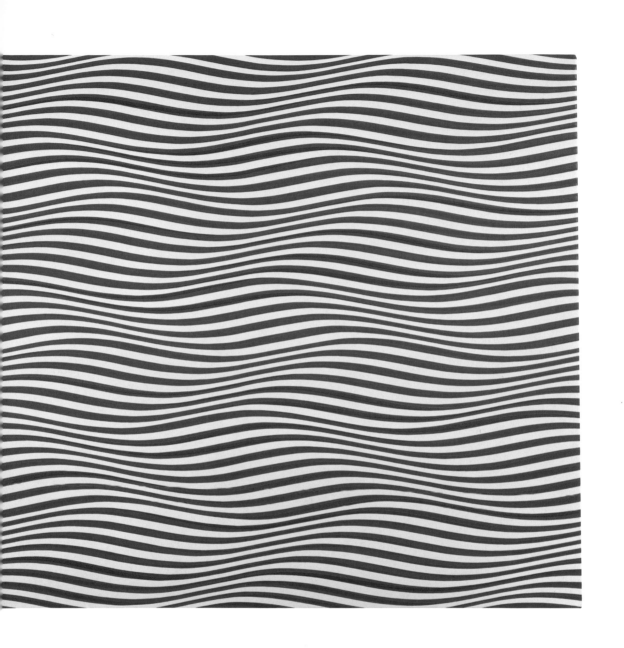

How far do you take this into account? Have you any particular ideal distance at which you would like to see your colour compositions viewed?

No, each painting is specific and its viewing distance is equally specific. But I have noticed in my own work and in other painters' that if an artist is working by response then the distance from which the work has been seen in the making, in the studio or wherever, is usually the one which perceptive spectators will instinctively take up on their own accord later on.

Thank you, Bridget Riley, for having told us such illuminating facts about your work and your experience.

1 'On the History of Landscape Painting', Lecture IV (1836).
 In C.R.Leslie, RA, *Memoirs of the Life of John Constable*,
 London 1951, p.323.

2 I. Stravinsky, *The Poetics of Music*, Cambridge (Mass.)
 1942, p.65.

3 Quoted from the exhibition catalogue *Bridget Riley.
 Paintings 1982-1992*, Nuremberg/London 1992, p.32.

4 'Bridget Riley in conversation with Robert Kudielka'
 (1973), reprinted in *The Eye's Mind: Bridget Riley*, London
 1999, p.83f.

5 Charles Blanc, 'Eugène Delacroix', *Gazette des Beaux Arts*,
 October 1864, p.6.

6 *The Elements of Drawing*, London 1857, Letter III, Section
 153 and footnote to Section 240.

7 'The basis of my paintings is this: that in each of them
 a particular situation is stated. Certain elements within
 that situation remain constant. Others precipitate the
 destruction of themselves by themselves. Recurrently,
 as a result of the cyclic movement of repose, disturbance
 and repose, the original situation is re-stated.'
 In 'Perception Is the Medium' (1965), reprinted in *The
 Eye's Mind*, p.66f.

8 Semir Zeki, 'The Visual Image in Mind and Brain',
 Scientific American, September 1992, pp.43-50.

9 E.A.Piron, *Eugène Delacroix. Sa Vie et ses Oeuvres*,
 Paris 1865, pp.416-18.

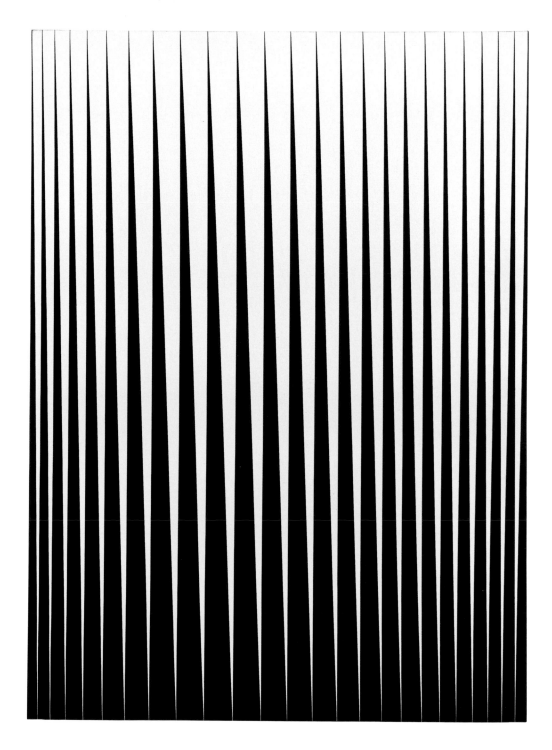

Breathe 1966

Practising Abstraction
talking to Michael Craig-Martin

There is a general view of contemporary British painting widely held by both its enthusiasts and its detractors that characterises it as essentially anti-modernist, traditionally and historically parochial, figurative, personal and expressionist, naturalistic or subdued, tonal in colour, pessimistic, confirming rather than questioning the well-established, allowing the viewer to bear witness to the artist's vision. Bridget Riley represents a very different strand of British painting: modernist and international, abstract, passionate and rigorous, optimistic and idealistic, committed to questioning, a new experience, engaging the direct and immediate experience of the individual viewer in a heightened experience of colour. She is emphatically a visual artist. Bridget, can I ask you straight away to say something about abstraction. Why abstraction?

I think the difficulty for many English people is that we tend here to think of pictures in terms of 'realism' as though a painting could be directly based on real experience – it simply can't. The variety in our European tradition shows it isn't – quite apart from the different solutions to picture-making in other cultures. In fact the only time that painting ever strayed into a concept of plain realism was in the nineteenth century. Before that and afterwards it has always been clear that painting is an invented reality. And so abstraction is necessarily its basis, no matter whether you paint figures or not. I've never at any point thought of myself as a particularly abstract painter – I can see that with the forms and colours I use I could obviously be considered so, but in the way that I move these things about I have never felt like that. I have always thought of myself as a painter.

So you see yourself as part of the long tradition of painting, the great tradition of Western painting, you see yourself in terms of the continuity of that tradition rather than a break with it?

Yes, I do. But there are traditions and traditions, there is one in bad painting, for instance, as well as in good. But a really good piece is

always fresh. It's amazing that some paintings from the past are so extraordinarily 'modern' while others, even some contemporary paintings, appear quite stale. It seems that painting presents certain problems with which artists inevitably have to come to terms no matter what period they happen to be working in. One of these lies in what is called 'pictorial space' and perhaps because of its recurrence as a problem it turns out to be one of the most interesting areas of invention. Precisely how and why an artist sets about 'the art of hollowing a flat surface', as painting has been described, tells you a great deal about him or her, about clarity of mind, about ability to order work, about purpose, and the interesting thing is that in good painting it is nearly always remarkably similar.

Do you mean similar through the ages? That it is one of the reasons why great painting from the past can be of such extraordinary contemporary relevance? It's not simply a historical object, it actually has living importance.

You are absolutely right. To treat them as historical documents or evidence of past concepts is wrong – they are particular solutions to continuing artistic problems, and it's that which makes them real, or as you say, 'living'.

I think this ties in with something which I've always felt myself, which is that there is very little in art which is truly new, but there are changes of focus, changes of attention, changes of what it is that the artist wishes you to concentrate on, to look at. And I would say that the difference between your paintings and the paintings of, say, Seurat is that there are similarities, but you have also changed what it is that you want to most draw attention to, and that's what constitutes the difference between your paintings – why they look different.

Seurat has been very important to me – in a way we both invent something to look at, though I, thanks to him, perhaps more deliberately. He had a dream of an art which could be verified and calculated. But his actual painterly achievement turned out quite differently.[1] It seems to me that when working on his great masterpieces, *La Grande Jatte* and *Les Poseuses,* he was depicting not so much an external reality as his own structure of sight. He would, naturally, have experienced such a projection as some curious reflection thrown up on the canvas before him and to cope with this genuine phantom as it emerged must have been quite

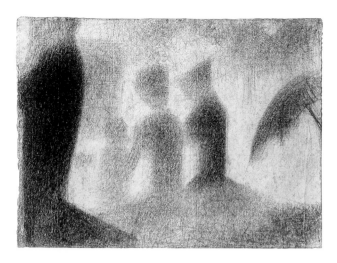

Georges Seurat: *Three Women (Study for 'Sunday Afternoon on the Island of La Grande Jatte')* 1884-85

difficult. His later work looks to me as though he became more and more upset by, perhaps even disappointed in, some aspects of the visual events he had so brilliantly created. For me it's different, as you say: I *want* to bring about a situation in which my work *can* throw up surprises. The perceptual medium is so strong, the elements that one is using – that all painters use – have the dynamics of natural forces.[2] They have their own laws, not rules but *laws*, and in a sense woe betide you if you upset the boat. But if one rocks it with an open mind, one may find unexpected things and in fact these are the fruitful germs. They may be awkward, they may be rough, they may be raw but they are the little nuggets out of which something might grow. I believe that they are the most precious things one can discover.

If I go back to your earliest work and look at that and then look at the work that you've done over the years, one of its primary characteristics is an extraordinary consistency of vision. I can look at what are for me your earliest publicly known works, and I can recognise the same vision, changed inevitably over the course of experience and time, but essentially a vision that found its roots quite early in that work. Is that correct, and could you say what it was that gave your work such a strong character so early?

Probably I would have to be outside myself to see that properly. People have often remarked on the specific character of my work. The only thing

I can say is that I don't aim for consistency, I simply try to move on or make some steady progress. I tremendously admire Mondrian who was so courageous in the *Boogie-Woogie* paintings he made at the end of his life in New York. He went right against his own work, putting totally at risk the stability and equilibrium which had been central of his achievement. I think he was right to do so – you have to change to keep your work fresh. One's procedures often appear to be the opposite of their real nature. It's as though a certain momentum demands opposition, reversal and

Piet Mondrian: *Broadway Boogie-Woogie* 1942-43

even contradiction. When my work needs to be re-thought, renewed, I often find a clue to the next step in identifying what I have come to rely upon most and challenging precisely that. For instance, in the 'stripe' paintings I made in the early eighties, I organised the sequence of colours quite freely – something I had not done before.[3] One of my previous strengths might have been considered to be a strict organisational rigour and so to shift over to a more intuitive basis felt like a loss of toughness. In a similar way I had come to rely upon a very pronounced form of colour interaction which meant using a strictly limited palette. If I wanted

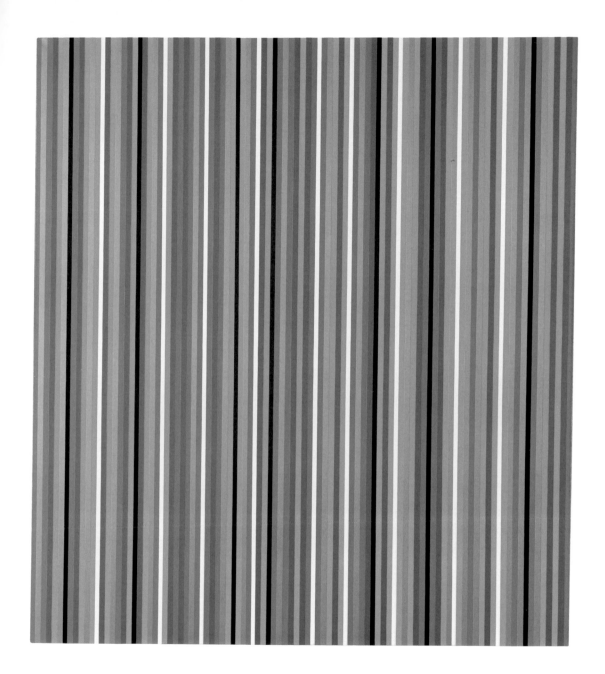

Winter Palace 1981

to go further I had no choice but to sacrifice both these procedures. In my new paintings I now have a wider range of possibilities, an open palette, and the colour interaction, whilst still very much there, is no longer the primary role of the colour.

Well, I can see, I think, exactly what you mean, that there are long periods in which the works are generating each other, in the doing of one you realise the possibility of another and then you do that, and this often carries you for a very long time. But there comes a point at which there's some kind of overload, there's some kind of build-up, and the break of a different character occurs, and that's the break that you're describing between the striped paintings and the newer paintings.

That's right. As you say there is a considerable difference in one's approach between the plateaus, so to speak, where the ground is stable and where one can exploit, develop, tool, if you like, and those periods when a radical re-orientation is necessary and the basis has to shift.

It seems to me that this is an experience – a double experience which all artists recognise. But very few people other than artists are really aware of how potent the difference of the experience of working is during those two phases.

Well, I think other people would have to know an artist's work extremely well or be able to survey it in some sort of retrospect to see what made a period and what was transitional and why. But, of course, when you are in the thick of it, it is crucial that you recognise the different demands your work is making as it unfolds. You must be able to judge and criticise yourself. To be a painter today one has to invent one's situation and criteria. You have to assess where you are and what you can accept or reject in your work. That kind of evaluation is simply part of the problem of being an artist now.

Did the same kind of clear break that you're describing occur when you went from the black and white and grey paintings to the very full colour paintings?

That was indeed a big step, although I think the step from the black and white work to the grey paintings was even bigger.

I ask this because the question of colour is obviously the most central question

to you, because there is a way in which you have built an extraordinary body of work on a confidence in the fact that colour can carry the day, that it can carry almost everything, it carries the visual, the emotional, the intellectual weight, a kind of visceral – you describe your work in a very visceral way, and it seems to me that all of that is characterised by how you deal with the colour.

I think that colour may be able to carry more, to be a broader vehicle than ever before since so much has happened to it and with it in the last hundred years.[4] As a painter now you have an enormous body of experience to draw on, a wealth of practice and insight accumulated by really brilliant people who have worked with it and thought about it. There is the painted experience, there is written experience and there are those things which one can deduce from where people went to paint and why – Tahiti or the South of France or just down the garden to the lily pond – a very carefully conceived and tended lily pond, to be sure. So I think one is extremely lucky in this regard. On the other hand, I must say that initially I simply did not know where to start – it was quite overwhelming. In fact, colour presented quite a crisis for me. In my black and white work I was dealing with staple, easily recognisable forms. If you think of a square, a circle, or a triangle, no matter what size it may be, you know exactly what form you can expect to see. But if you say red, yellow or blue you do not know at all what shade of colour you will be looking at. There is no certainty, no precise concept upon which you can rely. The reasoning of my black and white work could not be extended into colour because it depended on a contradiction between stability and disruption. I had to find a new basis and for a long time this eluded me,

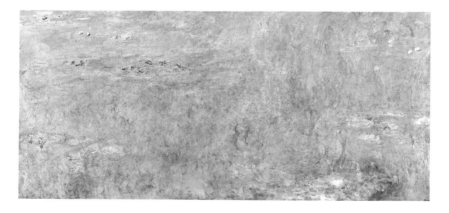

Claude Monet: *Water Lilies* after 1916

which was extremely blind of me, because I had already copied Seurat, and that should have told me certain things. But I had to wait about seven or eight years before I re-understood what I had actually been through. I saw that the basis of colour is its instability. Instead of searching for a *firm* foundation, I realised I had one in *the very opposite*.[5] That was solid ground again, so to speak, and by accepting this paradox I could begin to work with the fleeting, the elusive, with those things which disappear when you actually apply your attention hard and fast – and so a whole, huge area of activity, of perception, opened up for me. It was through this that I found out what I was looking at. What you focus upon is *not* what you see, at least not in terms of colour. I realised that what I was working with lay just outside the centre of attention. One looks *here* and colour is *there*. It's almost as though colour has no integral core or centre of its own. This, as you can imagine, was a huge discovery. And there too once I had realised it, I began to find traces back in early modern *plein-air* painting. In Monet's choice of non-subjects like water reflections or haystacks and in Cézanne's attachment to his mountain.

In the work that you do – when you're working – what constitutes for you a failure, something that's gone wrong? How do you recognise that?

I'm glad you ask me that because it is a crucial question. Recently I was showing a group of people round the studio and a man very politely asked me precisely that: 'How do you know when it goes wrong?' I could have kissed him! The answer is that I do not know, alas, at least not beforehand. I have to find out each time. I know the pictorial realities I must not offend and the most delicate of them all is the picture plane. Every painter knows that the picture plane is obviously not the same thing as the physical surface of the canvas – it is the invented plane in which the visual activity takes place, within which space advances or recedes – the stage, so to speak.[6] Now, that is very difficult to establish. You can't establish it in one go because you don't know where it is, where its limits and correspondences are in relation to one another. I find that a large part of the starting of a painting is taken up with making attempts to find this plane. I know it's there and once in place it will hold right across the area. It's the hallmark of good painting. Baudelaire is a great connoisseur and when one reads his criticism it's clear that the things he loves and praises in painting – air, movement, clarity of colour, order of mind, direct execution (that is to say, no showing off, no gratuitous brush work) –

Gala 1974

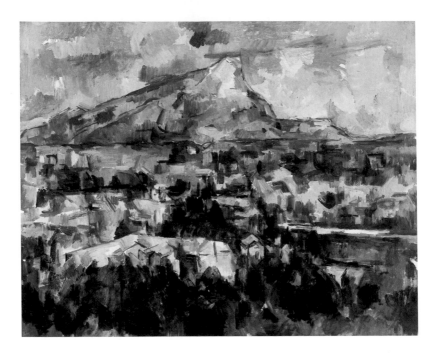

Paul Cézanne: *Mont Sainte-Victoire seen from Les Lauves* 1902-4

are all dependent on this primary condition. I also want these qualities in my paintings: air, movement, clarity. So I clean the colours, draw the rhythms, introduce spaces and particular places, trying to be as clear as I possibly can in what I'm doing.

This leads to another very interesting question about your work, about your method of work. You're unusual as a contemporary painter in that you have used assistants really for a very long time, and it's been a controversial question, I think, in your work, and I think this is extremely interesting. It's something which people take for granted with sculptors and yet somehow with painters, it's still controversial in modern times, at least perhaps less so today than it was twenty years ago. I wonder if you could say something about how you came to use assistants and how you work and what the role of the assistant is in relation to you?

It may sound strange to you but at the beginning – I have used assistants since my first black and white painting – this aspect of my work passed virtually without comment. Today there is more curious, conservative criticism of such a practice than there was when I started. In the sixties

people right across the board embraced the idea of the new with enthusiasm – very unusual for England. The new was seen as desirable, a positive notion in nearly every sphere, and in the arts this spirit took a radical form inconceivable now. In such a context my use of assistants was accepted as natural, as belonging to my work. I had been a student with considerable facility and I was quite used to being regarded as someone with talent and ability, and in my first black and white paintings I was deliberately turning my back on a lot of things like that. I wanted the actual content of the paintings to come through unchecked by any kind of touch, so that you could see the strength or weakness of something without any barrier.[7] I actually wanted a painting to be an extremely naked thing and to be able, for right or wrong, to make such clear decisions that there could be no doubt and no evasion.

So the use of assistants is integral to the paintings, because by executing them through a variety of 'other' hands the actual work itself becomes more clear. It's not that you couldn't have painted it yourself but the fact that it is carried out by somebody else is in itself part of the meaning of the painting?

Absolutely. It's part of the meaning of the work that I don't want to interfere with the experience of what can be *seen*.

Many people today think of abstraction and characterise abstraction as though it was detached from experience, as though the term itself – abstract – meant that it was not related to life, that it was not related to observation, that it existed in some kind of other realm and had no relevance for lived experience. Obviously that's not what you believe at all and I wonder if you could say something about that?

That is a very complex question. I will take the most difficult and most crucial point. Painting is, I think, inevitably an archaic activity and one that depends on spiritual values. One of the big crises in painting – at least a century or two, maybe even three centuries old – was precipitated by the dropping away of the support of a known spiritual context in which a creative impulse such as painting could find a place. This cannot be replaced by private worlds and reveries. As a painter today you have to work without that essential platform. But if one does not deceive oneself and accepts this lack of certainty, other things come into play – they may be the reverse of what one would expect. Rather like

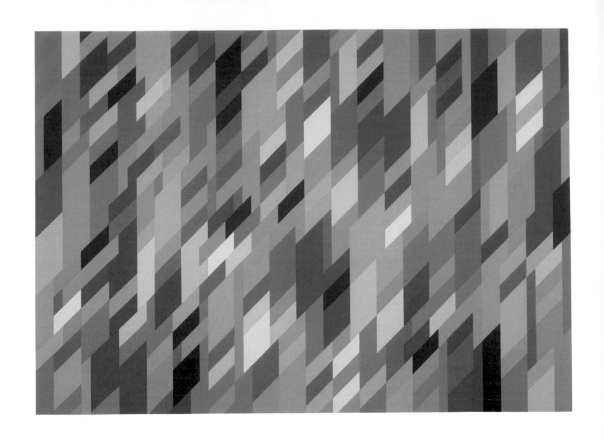

Reflection 1 1994

colour, whose instability can become another form of certainty. So the absence of something, especially something necessary but which cannot be easily identified or discovered, has sometimes led to a very exacting quest in modern art.[8] At the end of his life, Monet painted his largest, grandest and in many ways greatest paintings about virtually nothing; about looking into a huge expanse of water set with a few lilies in which unexpected colours appear in the depths, or elusively in reflections. It is a most mysterious, extraordinary subject in which he invests all his experience and power. In the end there seems to be hardly any subject matter left – only content.

1 See Riley's review of Seurat's centennial exhibition at the Grand Palais, Paris, 'The Artist's Eye: Seurat' (1991), reprinted in *The Eye's Mind: Bridget Riley*, London 1999, pp. 174-182.

2 The exploration of the 'energy' of the visual elements is discussed in a conversation with Maurice de Sausmarez in his monograph *Bridget Riley*, London 1970, pp. 57-63.

3 For this major change see 'According to Sensation: Bridget Riley in conversation with Robert Kudielka' (1990), reprinted in *The Eye's Mind*, pp. 114-120.

4 Bridget Riley, 'Colour for the Painter', in *Colour: Art and Science*, ed. Trevor Lamb and Janine Bourriau, Cambridge University Press 1995, pp. 31-64.

5 This point is developed in Riley's contribution to the catalogue *The Experience of Painting* (1989), reprinted in *The Eye's Mind*, p. 127.

6 An example of this is given in 'According to Sensation' (1990), see *The Eye's Mind*, p. 118.

7 Riley was very much impressed by Félix Fénéon's praise of Seurat's handling: 'Here in truth the accidents of the brush are futile and trickery is impossible; there is no place for bravura – let the hand be numb, but let the eye be agile, perspicacious, cunning' (from an article in *La Vogue*, 1886; quoted in John Rewald, *Seurat: A Biography*, London 1990, p. 108).

8 In *The Experience of Painting* (1989), Riley refers to Beckett and Proust as well as Monet, see *The Eye's Mind*, p. 122.

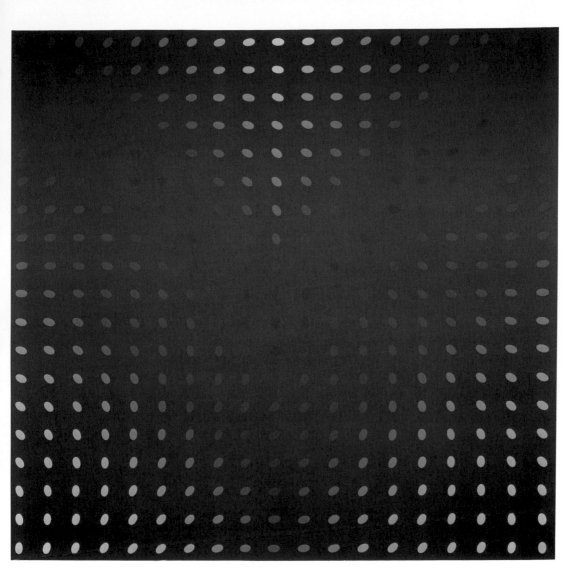

Deny 1 1966

A Reputation Reviewed

talking to Andrew Graham-Dixon

Bridget Riley, you've been famous as an abstract artist for more than thirty years. But there was a time at the start of your career when it all could have turned out very differently. Didn't you train as a figurative artist?

Yes, when I was a student figurative work was the 'norm' and I spent the first three, maybe even four years, drawing from the figure, which was a marvellous foundation and very important to me.

What did you get from it?

I learnt certain fundamentals: I learnt to order my thinking, to analyse, to see the thing as a whole, to go for the main thing, to find out what that 'main thing' consisted of in each particular situation, and to allow *that* to determine what followed. I learnt to waste, to throw away, I learnt that no matter what one might hope for – what one might project in one's own mind – what one might be imagining, that at the end of the day the work has to stand on its own. I also learnt, which is very important for any two-dimensional thinking, that you have to find ways of conveying such things as weight and space convincingly, without relying upon the mere representation of the model to do these things for you. It is not sufficient to depict, you have to make your drawing 'do it' in its own terms, autonomously.

That's very much an abstract artist talking about figurative art, it seems to me. I suppose a lot of people might say that you threw away your early training, you rejected it, you decided to go against it and turn yourself into an abstract artist. Do you think that's true, or do you think it fed into your practice as an abstract painter?

I think it fed in. Painting has always had to deal with abstract problems, and I first encountered them in the form of this exercise. An artist can very seldom use directly what he has learned in figurative drawing.

Bridget Riley: *Nude* c.1951

There simply isn't a direct extension – of course, there are a few artists who actually continue to be art school artists all their lives. But for most painters, it is an exercise, and that is what is so good about it. It's a method whereby one can discover enormously important pictorial facts, and through which you learn something which will allow you to work in whatever style or manner you later practise. You're not acquiring an external apparatus of some kind, you're learning how to work.

Do you still draw from the life?

No, I don't. That has long been over for me, but I found at the end of such a long time spent drawing, that I had run up against a very big difficulty. At the time I thought it was my own, only later I realised it was not so. This difficulty is the split between line and colour. It's the old argument between Ingres and Delacroix, the Poussinists and the Rubenists.

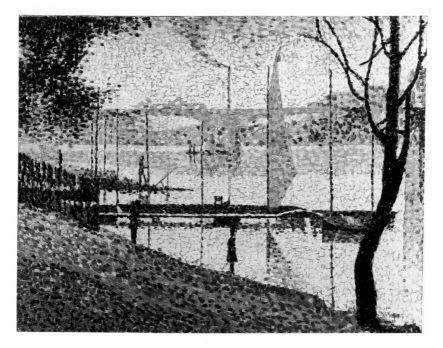

Bridget Riley: *Copy after Seurat's 'Le Pont de Courbevoie'* 1959

A contour does not necessarily describe a volume, and this poses great problems when your mind is working in one way, to get around to the other. Delacroix made this marvellous remark – *prendre par le milieu* – to take by the middle.[1] As you can imagine with a thing like a pencil, this is an extremely hard thing to do, although there have been great artists who have done so – Delacroix himself and of course, above all, Titian. It's a different way of thinking.

How much painting did you do when you were at art school?

Not very much. I had great difficulty with colour, and it wasn't until I made a copy of Seurat's little landscape, *Le Pont de Courbevoie*, that I began to find any kind of basis in it. It was a revelation, because Seurat, through his optical mixture, masses on his canvas colours which he then relates, gathering them into larger forms, dispersing them into open areas, and this moulding, moving about, shaping of colour masses, through these tiny, tiny dots, through these minute touches of colour, gave me a way which completely broke the hardness of the line.

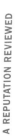

Now, that might sound perverse to some people, because you've just said that you've learnt about colour from Seurat, and the direct product of this was a painting which is black and white.

Yes, Seurat's thinking was based on contrast, primarily, and modified by the way colour spreads. The whole idea of contrast is fundamental to painting.

And your earliest paintings go for maximum contrast, black and white?

Yes, quite deliberately. I chose them for that reason.

A lot of people at the time saw them as being extremely aggressive, this hard, hard contrast of black and white and these dots that dance before your eyes, these curves that seemed to slip in and out of focus. They were literally disorientating. People found them worrying and disturbing and aggressive. Do you think they were right?

I think they were beautifully aggressive. Contrast is the clash of cymbals, the exclamation mark, the strongest possible means. That I wanted; I felt very much at the time like making an extreme statement, of something violent, something that definitely did disturb.

Were you an angry young woman?

I don't think it was so much that. I had my reasons for making such a statement, but also I was beginning to find my means.[2] An artist has to discover a way of working for himself, this is the modern problem. It's the greatest challenge and excitement, but it also inevitably lays one's work open to misunderstanding which, of course, is a pity. The adventurous side and the misunderstanding tend to go hand in hand, because in trying to find your own discipline, there's nothing to guide you. This is part of the pleasure of working today, but one is, at the same time, exposed to the very real danger of being put into a category or a position that one didn't intend.

That did very much happen to you, didn't it? Because talking about your invention of a personal language in terms of the Op art paintings, it very soon became not a personal language, because those paintings were copied, fabric

Kiss 1961

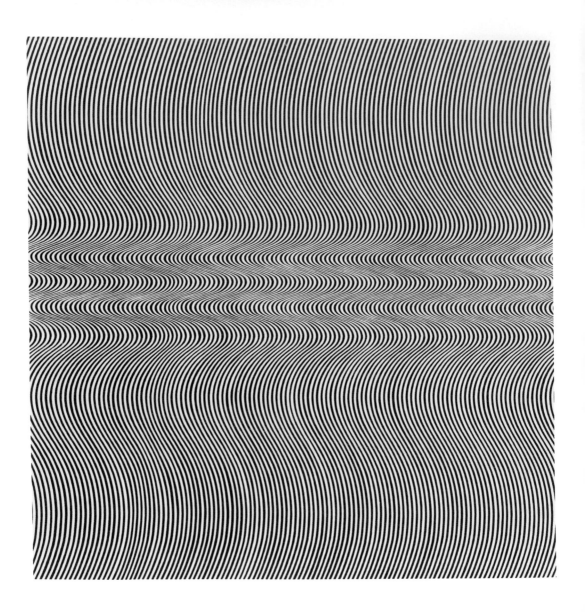

Current 1964

was made based on them, people designed dresses based on them, they became almost like designs for what the 1960s conceived of as its own style. So they stopped being your paintings, and they became cultural property, they were everywhere – Bridget Riley lampshades, Bridget Riley dresses, Bridget Riley sofas. How did you feel when that happened?

It really originated in New York, it was an extraordinary experience. I remember that I had absolutely no idea of what lay ahead when I arrived. I was driven from the airport down Madison Avenue, and to my amazement I saw windows full of versions of my paintings on dresses, in window displays, everywhere. My heart sank.

Window display of Richard Shops 1966

What had happened was that someone who was connected with the Museum of Modern Art and who also was a dress manufacturer had bought a painting of mine and made dresses based on it which other people in the fashion world immediately picked up. So the whole thing had spread everywhere even before I touched down at the airport.

You were in New York for the opening of The Responsive Eye, *which was a group show of contemporary art in the mid-1960s.[3] What was the opening like?*

It was astonishing, about half the people there were wearing clothes based on my paintings and I tried to avoid having to talk to the people who were

the most completely covered in 'me'. There was one member of the MOMA Council who was so furious that he said 'So, you don't like it? We'll have you on the back of every matchbox in Japan!'

That's a great story. I mean that seems to suggest that there was a kind of vengefulness involved in it anyway, that it was a form of not taking you seriously, it was almost like a protest against your art?

Certainly that's what I felt. But the American artists were wonderful, they gave me an enormous amount of support. They were horrified by what had happened, Barnett Newman in particular, who took me to his lawyer and I tried to take some legal action, only to find out that there was no copyright law in America. That only happened some time later, and Barney told me that it was nicknamed 'Bridget's Bill'.[4]

So you never made any money – people selling thousands of Bridget Riley dresses all over America, and you never made a penny out of it?

No, certainly not, I mean – it would have stuck in my throat. I could not have borne to have done so. I fought it in every way I could, in America and here in England, but it was too late, it was already done. I was cast in a role which I had not wanted and which I was not going to accept.[5] My work had been falsified. I remember coming back on the plane thinking that it would take twenty years before anybody could look at my paintings again.

So you became tremendously famous almost overnight, and yet it was the kind of fame that appalled you?

It was the kind of fame that would have appalled any artist, to become well known for work rendered by the same stroke disfigured and unrecognisable and that was a frightful thing to happen.

How did you cope with it?

I came across something that James Joyce said. He said there are certain times when there's only one proper defence for an artist, and that is to choose silence, exile and cunning.[6]

And where did silence, exile and cunning lead you?

It enabled me to continue my work.

Do you think that's why you changed your style, why you developed in a different direction, why you moved away from those aggressive Op art works?

No, it's more complicated. I had anyway already passed the most extreme point of optical intensity in 1963 with my painting *Blaze* – two years before I visited New York. And besides, I had no intention of working towards an ultimate statement of any sort; that kind of 'radicalism' simply did not interest me. The reductionist view of abstraction, whilst it had been essential in the early days of the century, was by the 1960s clearly no longer relevant. The Suprematists had purged the last traces of representation from the work of the Cubists, and the giants of early abstraction – Malevich, Rodchenko, Kandinsky and Mondrian – all regarded their work as a beginning, a foundation – not as an end. The vision that seemed both possible and desirable was the evolution of an abstract art whose vocabulary was *independent* of traditional cultural associations.

Did that idea appeal to you?

Yes. After all, European painting has always been international, except perhaps during the nineteenth century. The basis of its internationalism and rich variety was a shared common iconography – both Christian and mythological. To evolve a visual language that could serve as a sort of similar common ground seemed a wonderful idea. But the point about a visual language is that *it* must be expressive, that these elements – squares, circles, triangles, contrasts, harmonies, etc. – could express something when they were released from the burden of having to serve as agents for other meanings.[7]

What did that mean for the paintings, say, in your use of colour?

I had to give visual sensation more rein – my black and white paintings had been about states of being, states of composure and disturbance, but when I introduced colour in 1967 this began to change. Colour inevitably

leads you to the world outside; in *Late Morning* and the other paintings
I made in the late 1960s I was beginning to find my way with a whole host
of sensations to do with colour. But to start from these as I have in my
work since the early 1980s is quite a different thing. Sensations – visual
sensations – defy attention, the moment they are focussed upon they
evaporate; they are extremely elusive things.[8] We all have them, all day
long. But mostly our lives don't allow us to actually 'let them in' in their
original state. But if you walk through a landscape, you absorb sensations
of shadowy parts, massed forms, open spaces, hard rocks, things above
you, the earth beneath – they're not only visual sensations, they are
sensations which take in the freshness of the day, a wind that may be
blowing, clouds, rain in the air, a whole variety of accompanying feelings –
these are so fleeting that you can't separate them and nor do you want to.
But at the end of such a walk, you feel something has happened, although
you can't actually name it.

*Are you saying that painting has to be complicated because the world is
complicated?*

It must be complex – rather than complicated – we have only one nature
to go by and it's not a simple one.

Pierre-Auguste Renoir:
Anemones 1898

Now, obviously your paintings don't look like anything in particular, other than like themselves. I don't look at a Bridget Riley 'zig' painting and think, 'Oh, that reminds me of a walk in the woods I had last week.' But would you like me to think this is a visual experience as rich and as complicated in its own way as the walk I had in the woods last week?

I would like you to *recognise* the sensations, not necessarily, as you say, *as* a walk in the woods, but to know that you have somewhere in the past experienced a sharp juxtaposition, a softness of form, a surprising brilliance, a dusky, hidden thing, that you have felt the weight of things above and the lightness beneath. It's like Proust in reverse – or rather it's recognition, really, but of no specific instance, like Renoir when he compared a Delacroix battle scene with a bunch of flowers.[9] It's the recognition of the sensation without the actual incident which prompted it.

I suppose what we're really addressing here is the most awful and terrifying and imponderable problem of abstract painting, which is how and where and if it touches the world that we live in?

Eugène Delacroix: *Lion Hunt* 1861

Yes, but it's not only a problem for abstract painting. It is as difficult for figurative work or for any kind of concept 'to touch the world that we live in', as you put it – the deception there is only much bigger. You cannot intellectually guarantee such a contact. It's part of the risk you take as an artist that you limit yourself to the elements, the physical means of your art form. Your one and only chance is to mould and build relationships which reflect some truth. It's through relationship that everything happens.

Almost at the beginning of your career, you became quite astoundingly famous. You were a household name: there was Twiggy, there was Mary Quant, there was Bridget Riley. And now, although in some sense you're more respected as an artist, you're much less famous, you're not a household name any more. Does that matter to you?

No, it's much better now. Looking back over what happened, that was not the sort of fame I believe any artist would want. It destroyed my work in terms of reception, it meant people couldn't look at it. I'm much happier now because people are looking at my work, and after all, that's what counts.

1 Delacroix's distinction between 'taking by the middle' and 'starting with the contour' (*prendre par la ligne*) had a great influence on subsequent generations of artists, particularly on Van Gogh. The slogan as such cannot be found in his own writings but has been passed on through the recollections of Jean Gigoux, *Causeries sur les artistes de mon temps*, Paris 1885.

2 In autumn 1960 Bridget Riley went through a personal and artistic crisis. Her repeated attempts to paint one last, black picture eventually led to her first black and white paintings.

3 The exhibition opened in January 1965 and included a wide range of artists interested in 'perceptual abstraction', as William Seitz, the curator at MOMA who organised the show, described its theme. Riley was represented by two paintings of 1964: *Current* (from the collection of the Museum, Philip C. Johnson Fund) and *Hesitate* which was owned by Larry Aldrich, the dress manufacturer. Concurrently the Richard Feigen Gallery mounted an individual exhibition of her work which sold out before the opening.

4 The Bill was passed in 1966 and it said that the buyer of a work of art did not own the copyright unless the contract of the sale so stated.

5 Riley answered her critics in her article 'Perception is the Medium' (1965), reprinted in *The Eye's Mind: Bridget Riley*, London 1999, pp. 66-68.

6 'I will not serve that in which I no longer believe, whether it call itself my home, my fatherland, or my church: and I will try to express myself in some mode of life or art as freely as I can and as wholly as I can, using for my defence the only arms I allow myself to use – silence, exile and cunning.' From *A Portrait of the Artist as a Young Man*. Facsimile edition in 2 vols., pref. and arr. by H. W. Gabler, New York-London 1977, vol. II, p. 1191.

7 This is an essential prerequisite of Riley's approach to abstraction. Cf. 'In Conversation with Robert Kudielka' (1972) reprinted in *The Eye's Mind*, p. 82: 'When I started, around 1960, forms such as triangles, squares, circles, rhomboids, etc. were no longer burdened by the heavy load of associations and symbolic overtones which they had carried in the 20s and 30s as Constructivist motifs.'

8 For the elusiveness of sensation see 'The Pleasures of Sight' (1984), reprinted in *The Eye's Mind*, p. 32 f.

9 Ambroise Vollard reports that on a visit to Cagnes in 1916 Renoir showed him a painting of flowers which he had just finished, saying: 'Look, Vollard, isn't it sparkling almost like a battle by Delacroix? … I am pretty sure this time that I have got the secret of painting!' (*La Vie et L'Oeuvre de Pierre-Auguste Renoir*, Paris 1919, p. 12).

Things to Enjoy
talking to Bryan Robertson

*Bridget, is there any place in England, a town or village, a stretch of coast or
countryside that you especially enjoy and want to retreat to when you need
to recuperate from the stresses of living and working in London?*

I think that would be Cornwall. I spent most of my childhood there –
the landscape is rich and varied, it can be intimate and small in scale or
grand and simple – it's continually doing something different. There are
the changes between the tiny valleys where every plant seems significant,
and the rolling expanse of the big seas which dwarf everything else, and
the changes of the weather. Life outside played a large part. My mother's
great idea – and solution to most things – was 'let's go out for a walk'.[1]
The other wonderful thing about Cornwall was reading. My mother read
to us in the evening or when the weather was bad. She read most of the
English classics: *Wuthering Heights, Treasure Island, Vanity Fair, Sense
and Sensibility*; a lot of Dickens, a little Walter Scott, and the Old and
New Testaments.

*But Cornwall itself, to me at any rate, is synonymous with brilliant colour
and sharp, clear light. That must have had an effect on you, when you were
a child?*

To me, the colours always seemed to be soft. One is very aware of greys –
there is a wide range of subtle shades of greys, warm and cold – coloured
greys in the slate of the rocks and stone walls, the colours of the sea, the
sky, and the mists that are never far away. There is also a sense of fine
detail of texture in the lichens, mosses, streams, pools and little trees.
I think the fact that there was always something different to look at was
a very important part of my expectation of what going out was all about.

*Has Cornwall receded into the past or do you manage to keep any contact
with it?*

Bodmin Moor, Cornwall

Yes I do – in that I still have a studio there. But I think what really matters more is that I find it again in other places in other countries, even quite unexpectedly – in Japan, for instance.

Now, apart from working in London, it is known that you have a studio in France. How did the idea of working abroad ever present itself in the first place? It's quite a step to take; how did your contact with Provence come about?

It was an adventure…

As a student?

No, I was a little older than that. In 1962 I went there to stay with some friends. I didn't realise then that it was such a celebrated part of the world – or that it had been lived in and loved by artists and poets since the time of Petrarch. To me it was simply the most overwhelmingly beautiful landscape I had ever seen. It had the qualities of Cornwall, but intensified and heightened by being so close to the Mediterranean.

Well that's exactly how I feel, because without any kind of solemnity of great ruins, or remains, there's a tremendous feeling of age, of antiquity, of a landscape that's been lived in for thousands of years, and worked – like Cornwall.

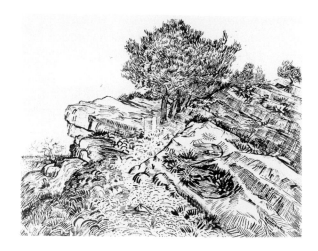

Vincent van Gogh: *Rock with Trees: Montmajour* 1888

Yes, that's absolutely true – the sense of an ancient landscape, of the harshness as well as the splendour. If one walks in the *garrigues*, in the stony dry hills where only scrub and stunted oaks can grow – you lift a stone, scaldingly hot in the sun, one side grey and lichened from years of exposure, the other luminous, golden, seemingly fresh, like the earth it's been lying close to for so long, undisturbed for centuries. The difference in the two surfaces is startling – it's very much like the place itself. It seems to be so worn, so old – and yet untouched, never seen before.

Do you think the particular quality – the nature – of French light and colour, the physical reality of that countryside around you in Provence, affects your work?

Yes, obliquely. After a while, certain feelings appear in my work – but I do not look for the particular in the sensations I experience there; I deliberately avoid carrying any sort of image or combination of local colours back into the studio – that simply does not work. I have tried it in the past and it is the sort of mistake you make at the beginning. If I am outside in nature, I do not look *for* something or *at* things, I try to absorb sensations without censoring them, without identifying them. I want them to come out through the pores of my eyes, as it were – on a particular level of their own.

Do you like, as I do, Picasso's remark, almost a cliché by now – it's been quoted so often – 'I don't work from nature, I work parallel with nature'.[2] Does that seem to you the right sort of approach?

It's a wonderful statement of Picasso's, and so is Jackson Pollock's 'I am nature'.[3] The relationship of all artists to nature is important and it can be very different. I am working towards nature.

That's interesting – could you say more about that?

Well, I start from my materials, from the colours and forms, and eventually I may recognise in them particular relationships, sensations somehow familiar from nature.

I like Gertrude Stein's funny remark, quoted in The Autobiography of Alice B. Toklas: *'I like a good view, and I like to sit with my back to it'. I think that's probably the best approach to nature for most artists working abstractly.*

She should be shot!

What does affect you in nature? Is it the countryside of different places, on its own terms, or is it the reflection of that countryside in terms of the culture of a country? When I walk in Tuscany, for instance, I can't help seeing people working in the street or repairing the roof of a house, and they suddenly look as though they have come out of a wonderful Masaccio. Or you see people working in the fields and they look like the background of a Bellini painting. In Provence it seems very hard to avoid the feeling that Cézanne and van Gogh had worked there. How is it for you? Do you manage to keep the two things separate in your mind?

Well, there is, inevitably, an undercurrent from the tremendous artists who have worked in that part of France. Aix is only sixty miles away; Arles about fifty; and Nice – a couple of hundred. And of course you sometimes see images or experience the sensations which you find in their paintings. But the reason for my going there is not to 'see through their eyes' as such – it's more that their love of the Midi confirms my own. Nature is very powerful indeed down there; it can be quite overwhelming. It's not only a visual experience – there are the sounds of the insects, the scents, the heat of the sun, the force of the winds, even the violence of the storms – it's the entire thing.

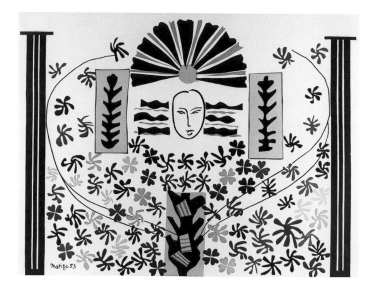

Henri Matisse: *Apollo* 1953

So the physical reality of Provence eliminates any sense of Cézanne having been there first, or Van Gogh? Can one see it on its own terms?

Indeed. I think one of the most important things is the ever-changing character of Provence. It's something you can't ignore. Maybe it's due to the brilliance of the light, or the atmosphere close to the sea – in any case the result is a continuous shift in what one sees. Within a few minutes everything has re-related in front of your eyes.

Do you think that some other journeys you've made, for example to India, to Egypt and to Japan, have been perhaps more cultural pilgrimages, or not? Have you been as much affected by the physical reality of those places as by cultural connotations and the works of art experienced there?

I think it would be impossible to go to Egypt and be unaware of the enormous area of light-mirroring desert on each side of the Nile, the whiteness of it, the dazzle of it and the purity of air this particular landscape creates, threaded as it is by long parallel lines of strongly coloured vegetation and by the blue shades in the river itself. It provides a perfect context for Egyptian art and its monuments – one immediately sees why the ancient civilisation used such brilliant colours.[4]

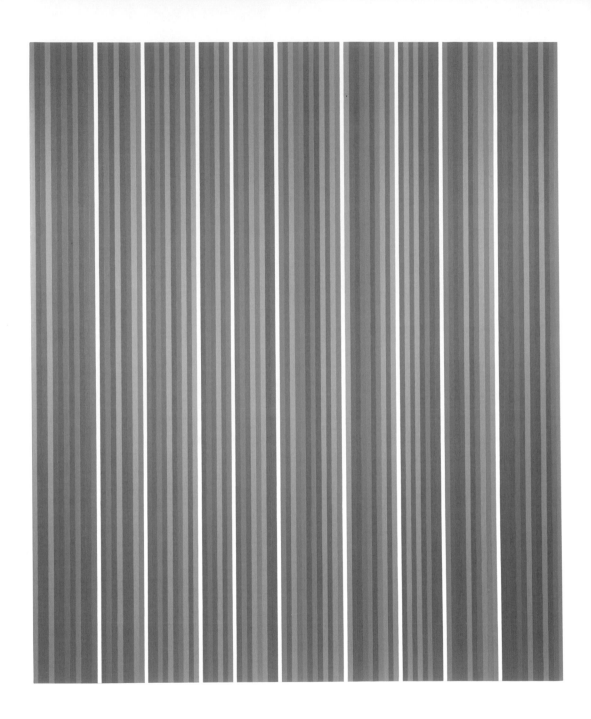

Bali 1983

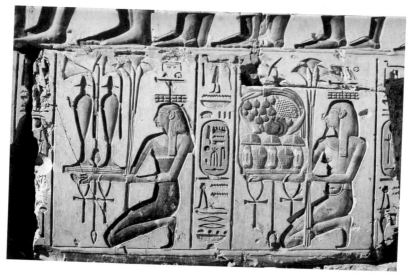

Relief from the temple of Ramses at Abydos
(on the right the turquoise-coloured Nile god offering his presents)

What about India, the life, the feeling, the seething mass of it?

It's by far the most vital country I have ever visited. When you say teeming, that, I think, is the impression. Everything seems to be generating and re-generating – turning over – proliferating in all directions. And it happens on such a scale: there are other countries which are big, but India is vast and a vastness soaked with people, densely inhabited for centuries, walked on, built on, slept on. India was far more beautiful than I had thought it would be. I had no idea that dawns or dusks could have such strong turquoises, bronzes, pinks.

Did you visit one particular part? The North or the South, for instance?

Mainly the South and Centre, visiting Hindu temples in particular.[6] The early ones which I saw in Mahablipuram are carved out of the living rock – at first in caves and later free-standing. All the surfaces are, like the country itself, full to the brim: Gods, chariots, animals, human beings, plants, houses and shrines – innumerable tiny carvings. And what was once a single temple becomes a unit in a bigger one – a sort of extraordinary multiplication. Another marvel is the Indian literary tradition. The Mahabharata, their ancient epic, supposed to have been

Yes.

How about your two studios in London: is the use of these in any way recreational – in terms of light, space and habitation?

Well, the fact that I go on a journey, even though it's only a small journey, is very important. I go from the space of my house, with its enclosed garden, to the flat industrial landscape of the East End, with its enormous, wide, open sky and I love that change. I very much enjoy being in a city in the sense of travelling on the Underground, being with people, watching them, and taking part in that way.

What are the practical reasons that necessitate two studios?

In the East End studio I do all the real work, the creative work on my paintings, and in my studio at home everything is arranged for execution and practical support.

Your second studio, Bridget, is entirely reserved for you alone, your assistants don't go there?

No, apart from privacy the most important thing it does for me is to provide a distance in space and time. That is to say I work on something, I go away from it and return to it. Sometimes I am very excited about what I am doing. I feel that I have really got something and I carry away in my mind the *condition* of the work. Now, despite the separation my mind goes on working on what I have been doing without my being aware of it – absently. So when I come down next morning and we meet again I see the work in a different way – more than just afresh. My mind might have resolved something uncensored by conscious efforts, and this is a great advantage. I have found that if I stay on in my second studio I lose this, even if I cover the work.

Are you reading much nowadays and do you have certain preferences?

I have a series of loves, like all people who read to find things out and for excitement. One of the milestones was Proust; his *Remembrance of Things Past* is a precise account of 'making'. To me it seems to chart the entire process of creativity and one of the high points takes place in the very last book, when he goes to a reception at the Guermantes'. He's exhausted,

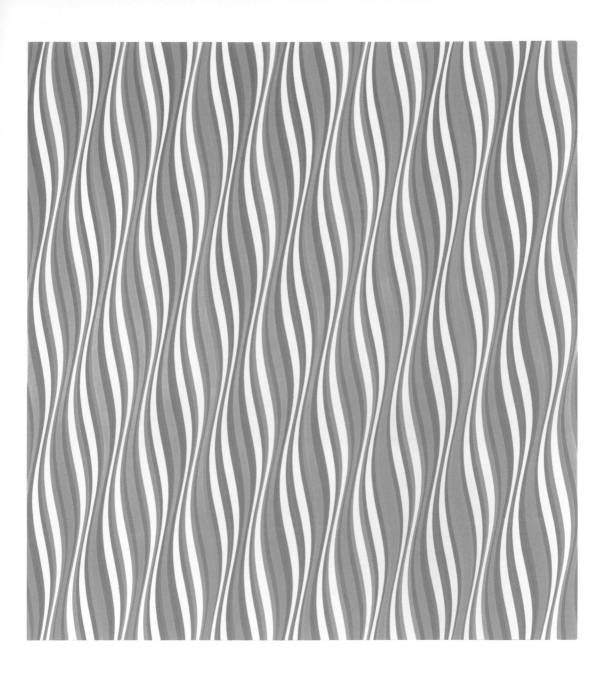

Entice 2 1974

tired, depressed, sickened by himself as an artist and his failure to find either subject matter or a method of working, then something happens that shows him that he has been looking for all the wrong things, for something too big, too obvious and too anticipated. He steps out of his carriage onto a cobblestone, and his foot slips. In that second, a wonderful happiness comes over him. Involuntarily he remembers his foot slipping on a comparable stone in Venice, and the whole of Venice, which he had not been able to recall deliberately and which had eluded him when he had applied his conscious mind to it, floods back. He feels the chill of the night, he can see St Mark's Square and smell the sea – everything essential is vividly present.

Of course one of the things that comes through constantly is the power of imaginative time as opposed to real factual time. Did that appeal to you, the sense of the artist's imagination triumphing?

Absolutely. As you say, this power of the imagination is evident in the way Proust moulds his narrative right through all twelve successive books, and this according to the invented pace of a purely plastic time. I think that one of the things he puts into the mouth of his painter, Elstir, is the key to this. In the last volume, *Time Regained*, Elstir says that you must give up that which you love in order to re-create it.[7]

Do you think Elstir was based on Monet?

He probably was, at least in parts – as far as subject matter and the coastal site in northern France are concerned.

Do you read with pleasure any writers on art, I mean distinguished figures such as Fromentin and Ruskin, or Delacroix in his Journals, *or do you try to avoid all that?*

I have loved Delacroix's *Journal*, and Paul Valéry, and Stravinsky of course...

Stravinsky's Poetics of Music?

Stravinsky's *Poetics of Music*, Valéry's *Poetics of Making*, they are very much linked.

In what way?

Well, in 1939 Stravinsky had asked Valéry to check his French manuscript just before his emigration; and he later said that what he missed most in America was the wisdom of Valéry.[8]

What sort of wisdom?

Limits, I suppose, the idea of creative limitation, the pluses and minuses of this. Valéry's judgement is better balanced than Stravinsky's on this point.

All this sounds extremely fascinating – but very serious reading. Do you ever read anything for pure relaxation?

I find books like that actually relaxing because I find them exciting and writers like that have something to say – that's what makes them wonderful to read.

Do you ever enjoy any real true leisure, in the sense of actually spending time just doing anything you like? Or are you, as most artists are, a seven-day-a-week worker? Do you have to fight for time for leisure, or do you make it each week, or what?

I don't quite know what you mean by leisure because within working, within the things I am doing, there is leisure, there is an ebb and a flow, a rhythm which takes into account both the need for repose, and the need for activity.

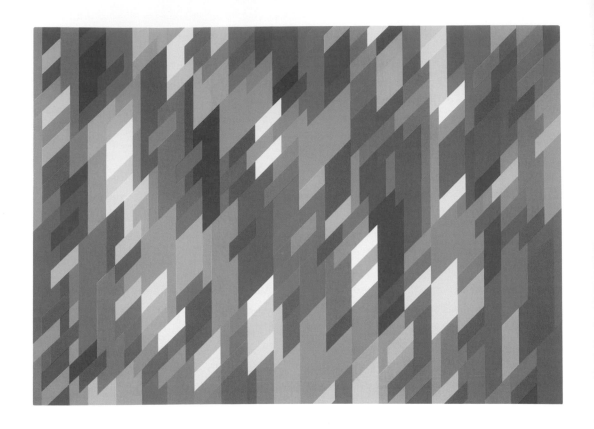

August 1995

1 Riley's childhood in Cornwall and the important role of her mother are described in a personal interview by Nikki Henriques (1998), reprinted in *The Eye's Mind: Bridget Riley*, London 1999, pp. 21-29. A truly poetic celebration of this childhood and its influence on her delight in 'looking' is given in 'The Pleasures of Sight', reprinted *loc. cit.*, pp. 30-34.

2 Picasso's classic explanation of Cubism. Cf. Françoise Gilot-Carlton Lake, *Life with Picasso*, New York 1964, p. 77: 'You see, one of the fundamental points about Cubism is this: not only did we try to displace reality; reality was no longer in the object. Reality was in the painting … We always had the idea that we were realists, in the sense of the Chinese who said, "I don't imitate nature; I work like her."'

3 From Bruce Glaser, 'Jackson Pollock: An Interview with Lee Krasner', in *Arts Magazine*, 41, April 1967, p. 38.

4 The visit to Egypt in December 1979 to January 1980 prompted a change in Riley's use of colour. Cf. *Bridget Riley: Paintings 1982-1992*, Nuremberg/London 1992, p. 30 f.

5 There were two visits to India. On the first, a stopover on the way to Japan in March 1977, Riley visited the cave temples of Elephanta, Ellora and Ajanta. The second, in the winter of 1981-82, was an extensive journey to the great sites of Indian sculpture and architecture. It included the Southern temples around Tanjore and Kanchi, Bhubaneshwar, Sarnath, Khajuraho and Sanchi. See also 'Holidays' (1996), reprinted in *The Eye's Mind*, p. 45 f.

6 Riley first went to Japan in 1977 at the invitation of Kusuo Shimizu, who was showing her work in the Minami Gallery, Tokyo. Thanks to his generosity she was able to visit almost all the important sites around Kyoto and Nara. She returned in 1980 for the opening of her retrospective exhibition in the National Museum of Modern Art.

7 Riley read Proust in C. K. Scott Moncrieff's translation which tones down the critical remark: 'You can make a new version of what you love only by first renouncing it' (*Remembrance of Things Past*, Vol. 12, London 1931, p. 467). Her understanding is closer to the axiomatic nature of the French original: 'On ne peut refaire ce qu'on aime qu'en le renonçant' (*À la Recherche du Temps perdu*, 3 vols., Paris 1945, vol. III, p. 1043).

8 Igor Stravinsky and Robert Craft, *Memories and Commentaries*, London 1960, p. 74.

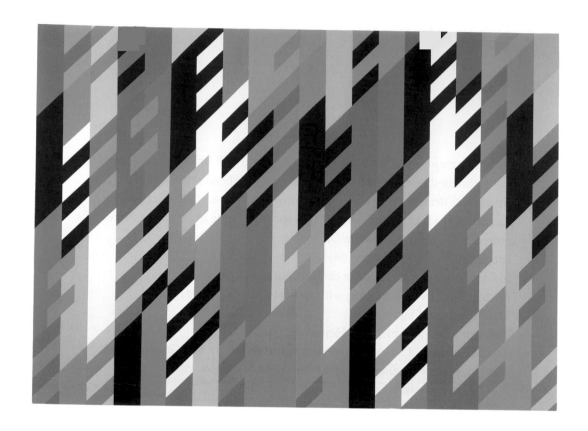

Justinian 1988

Biographical Notes

Bridget Riley was born in London in 1931. Her childhood was spent in Cornwall during the War. At the age of eighteen she went to Goldsmiths College of Art where she devoted almost all her time to life drawing. She continued her studies at the Royal College of Art (1952). The following three years were spent in uncertainty and in the search for a direction. In 1959 Riley discovered Seurat and after a personal and artistic crisis in 1960 she painted her first black and white paintings. She rapidly gained recognition and, as a result of the *Responsive Eye* exhibition at the Museum of Modern Art in New York in 1965, played a leading role in the emerging Op art movement. Between 1965 and 1967 she worked with coloured greys and exhibited her first paintings in pure colour. In 1968 Bridget Riley won the International Prize at the Venice Biennale. Her first large retrospective toured the European cities of Hanover, Berne, Düsseldorf, Turin, London and Prague in 1970-72. A second retrospective was shown in the United States, Australia and Japan in 1978-80. This was a period of extensive travel and included a visit to Egypt in the winter of 1979-80 which had a decisive influence on her approach to colour. Riley began to rely more directly upon sensation in building rhythms of vertical colour bands and in 1986 a powerful dynamic diagonal appeared in her work. This particular development was presented in an exhibition titled *According to Sensation: Bridget Riley, Paintings 1982-1992* which was first shown in Nuremberg, Bottrop, London and Birmingham.

As a result of renewed interest in her work the BBC produced a series of programmes which provided the basis for *Dialogues on Art*. Riley was made an Honorary Doctor of the universities of Oxford (1993) and Cambridge (1995). In 1996 she selected on behalf of the Tate Gallery the exhibition *Mondrian: Nature to Abstraction* from the collection of the Gemeentemuseum, the Hague. Meanwhile her own work began to change again. The introduction of circular and curvilinear forms into her developed rhomboid structures precipitated a major change in orientation. In the late 1990s a series of retrospective exhibitions in England and on the continent established her reputation as one of the leading abstract artists of her generation, On the occasion of her show *Paintings from the 1960s and 70s* at the Serpentine Gallery, London (1999), a collection of her writings and

interviews, *The Eye's Mind: Bridget Riley*, was published. In 2001 *Bridget Riley: Reconnaissance* (2001-2002) at the Dia Center for the Arts in New York co-incided with a show of more recent paintings at PaceWildenstein. Together these exhibitions marked a major revaluation of her work in the United States. The following year *Paul Klee: The Nature of Creation* (jointly curated by Riley and Robert Kudielka) opened at the Hayward Gallery, London, and the Museum Haus Esters/Kaiser Wilhelm Museum in Krefeld presented a first survey of her most recent work, including large, two-part canvases of curvilinear rhythms in a limited range of colours. A major survey of her work spanning four decades opened at Tate Britain in the summer of 2003.

Contributors

Neil MacGregor was Editor of *The Burlington Magazine* from 1981 to 1986 when he was appointed Director of the National Gallery, London. In October 2002 he became Director of the British Museum.

The late **Sir Ernst Gombrich** was Director of the Warburg Institute, at the University of London, from 1959 to 1976. Apart from his hugely popular *The Story of Art* (1950), his books include *Art and Illusion* (1960) and *Meditations on a Hobby Horse* (1963). His final book *The Preference for the Primitive* was published posthumously in 2002.

Michael Craig-Martin is well known as an artist and teacher and was appointed the first Millard Professor of Fine Art at Goldsmiths College, University of London, in 1994. A retrospective of his work was held at the Whitechapel Art Gallery, London, in 1989-90.

Andrew Graham-Dixon was chief art critic for *The Independent* between 1986 and 1998. In the 1980s he won the BP Arts Journalism Award for three consecutive years and, in 1991, the Hawthornden Prize for Art Criticism. Among his books are *A History of British Art* and *Renaissance*, both accompanying highly acclaimed television series.

The late **Bryan Robertson** was a writer, lecturer and broadcaster on art. His publications included *Jackson Pollock* (1960), *Sidney Nolan* (1961) and *Private View* (1965). He was Director of the Whitechapel Art Gallery, London, from 1952 to 1968. In 1971 he curated *Bridget Riley: Paintings and Drawings 1951-71* at the Hayward Gallery, London, and the Raoul Dufy retrospective at the same gallery in 1983-84.

Richard Shone is Editor of *The Burlington Magazine*. He has written several books on British and French art and was co-selector of the Sickert retrospective at the Royal Academy, London, in 1990. In 1999 he curated *The Art of Bloomsbury* at the Tate Gallery, London.

Robert Kudielka is Professor of Aesthetics and Philosophy of Art at the University of the Arts in Berlin.

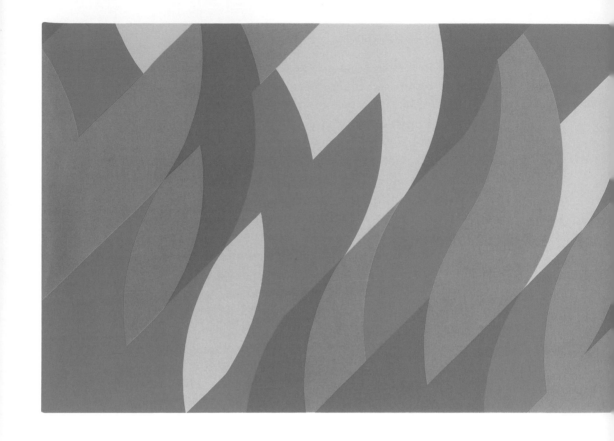

Paired Colours 2001

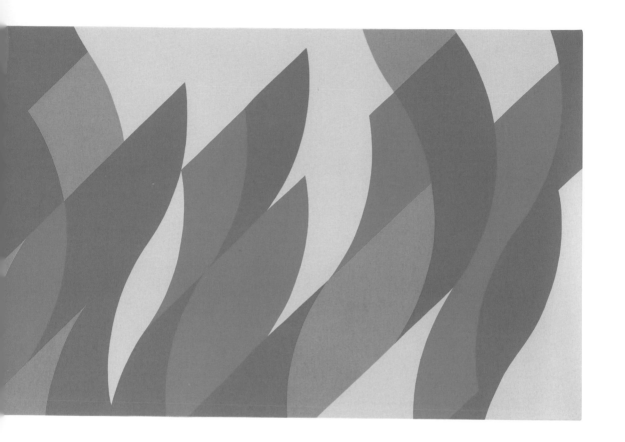

Bridget Riley: works illustrated

Other illustrations

p. 78
Pierre-Auguste Renoir
Anemones
1898
oil on canvas
22¾×17⅞ inches / 57.8×45.3 cm
Formerly J. Rosenberg Gallery, New York

p. 79
Eugène Delacroix
Lion Hunt
1861
oil on canvas
30×38⅝ inches / 76.3×98.2 cm
The Art Institute of Chicago

p. 84
Bodmin Moor, Cornwall

p. 85
Vincent van Gogh
Rock with Trees: Montmajour
1888
pencil and ink on paper
19⅜×24 inches / 49.2×60.9 cm
Rijksmuseum Vincent van Gogh, Amsterdam

p. 87
Henri Matisse
Apollo
1953
cut-out gouached paper
128¾×166½ inches / 327×423 cm
Moderne Museet, Stockholm

p. 89
Relief from the temple of Ramses at Abydos

p. 90
The Brihadeshvara Temple, Tanjore
(and detail of the façade)

p. 91
Stone garden of Ryoan-ji, Kyoto

Photographic Credits

The Art Institute of Chicago (p. 79)
Courtesy British Council, London (p. 37)
National Gallery, London (pp. 21, 22, 24, 59)
Geoffrey Clements, London (p. 31)
Prudence Cuming Associates (pp. 32, 39, 48-49, 51, 57, 61, 73, 93, 96)
Jan Janchuiewicz (p. 66)
Robert Kudielka (pp. 89, 90)
Larkin Bros Ltd (p. 75)
Moderna Museet, Stockholm (p. 87)
Philadelphia Museum of Art (p. 62)
Courtesy Ridinghouse, London (p. 2)
Rijksmuseum Vincent van Gogh, Amsterdam (p. 85)
Paul Rosenberg Gallery, New York (p. 73)
Scala Florence (p. 56)
Smith College Museum of Art, Northampton, Mass. by permission (p. 55)
Tate, London (p. 19)
John Webb, London (pp. 11, 19, 42, 44, 64, 70, 71, 85, 92, 100)